PHOTOREALISTIC
Colored Pencil

DRAWING WORKBOOK

Learn Essential
Techniques
through
16 Projects

Introduction

Welcome to the vibrant world of colored-pencil drawing! This workbook is your guide to unlocking the secrets of creating photorealistic drawings that burst with life and color. Dive into the rich palette of techniques, step-by-step guidance, and traceable sketches that will elevate your colored-pencil creations to stunning levels of realism.

Most people used colored pencils in their childhood, so it's no exaggeration to call them one of the most familiar drawing tools out there. Their unique appeal lies in their overwhelming convenience. Anyone with paper and colored pencils can start drawing a picture whenever they want, with no special tools needed for adding and mixing colors. And when you've finished drawing, it's quick and easy to put everything away. Colored pencils also offer a deep and rich appeal because of their excellence as an art material with a genuinely wide range of artistic expression depending on how they are used.

Something that can be frustrating when it comes to all picture drawing, not just colored-pencil drawing, is the underlying sketch that forms the base of the picture. To help you with that, we have provided a rough sketch for all 16 pictures. You can either directly color in the rough sketches in the appendix, or practice over and over again by tracing them on to your own drawing paper. The choice is yours.

This book also serves as a technique manual, as it introduces many techniques from basic instructions for using colored pencils, to color selection and color mixing, as well as practical techniques developed by the artists themselves. Whether you're a seasoned artist or just starting your creative journey, prepare to embark on an inspiring and colorful adventure in the realm of photorealistic drawing.

July 31, 2023

irodoreal (representative: Bonbon)

CONTENTS

PART 2

Basic Photorealistic Colored-Pencil Drawing
PICTURES

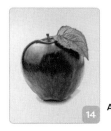
APPLE 14

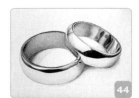
GREEN GRAPES 20

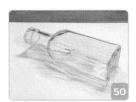
SALMON SUSHI 26

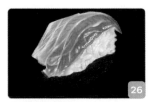
FRUIT TART 32

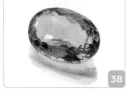
GEM 38

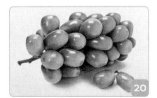
METAL RINGS 44

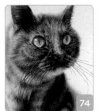
GLASS BOTTLE 50

BEETLE 56

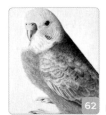
PARAKEET 62

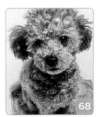
PUPPY 68

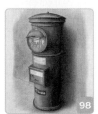
CAT 74

SNAKE 80

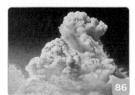
CLOUDS 86

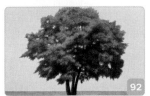
TREE 92

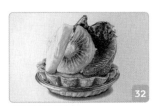
MAILBOX 98

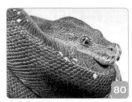
WOODEN WALLS 104

APPENDIX ROUGH SKETCHES FOR COLORING IN

HOW TO USE THIS BOOK

- Cut out/tear out the sketching paper containing the rough sketches in the Appendix and draw over them while looking at the page that explains the work.
- Use the sketching paper as many times as you like by copying the rough sketches onto drawing paper with a photocopy style tracing method (see below).

❯ PHOTOCOPY STYLE TRACING

1 Place a sheet of photocopy paper on top of the sketching paper. If you have a lightbox, place the sketching paper and the photocopy paper over it.

2 Copy the sketch with a pencil. If you are worried about the paper moving, fasten it with removable tape at the four corners, or on both the left and right sides.

3 Remove the sketching paper and turn over the photocopy paper with the rough sketch.

4 With the paper still turned over, shade in only the copied area darkly with a pencil. The rough sketch will appear on the other (front) side of the paper, while this turned-over side will remain shaded.

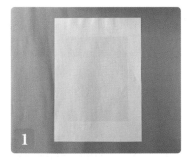

5 Place the paper from Step **4** on top of the paper that you want to create your drawing on, with the shaded side facing down.

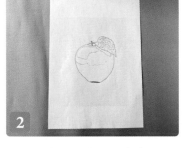

6 If you trace the copied rough sketch with a pencil carefully and quite firmly, the rough sketch will appear, and you'll be ready to begin coloring.

Basic Photorealistic Colored-Pencil Drawing

KNOWLEDGE

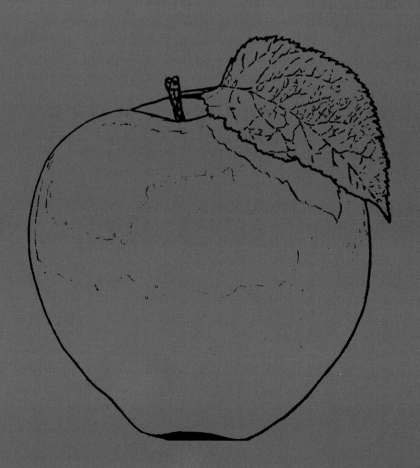

Basic Photorealistic Colored-Pencil Drawing
Knowledge

This section introduces the basic knowledge you need to know when drawing realistic colored-pencil drawings, including the tools you'll need, useful items, and basic techniques, such as how to apply color, use a stylus, and add highlights.

1 Required Tools & Necessary Items

Colored Pencils

Broadly speaking, there are two types of colored pencils—oil based and water based. There are also differences in terms of the drawing sensation, hardness of the lead, the types of colors, and the way the colors are produced—these factors vary depending on the manufacturer.

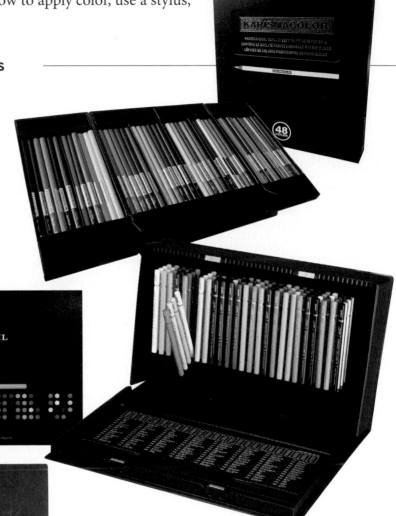

Photo: Charisma Colors, set of 48 colored pencils
Mitsubishi Uni Colored Pencils, set of 100 colors

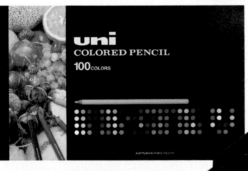

Paper

Just like with colored pencils, there are also various types of paper that can be used. We recommend that you use the Kent paper that is used in this book, because it is easy to draw on and produces good colors. We recommend that you draw with the colored pencils used in the works shown in this book, use the colored pencils that suit you best, or use different colored pencils depending on the effects you want to achieve.

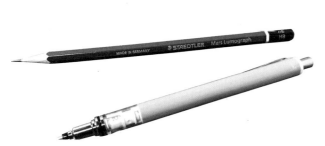

Pencils and Sharp Pencils

These are used mainly to draw rough sketches. The thickness of the lead is up to you, but thinner leads are more suitable for detailed drawing. If you are using a soft dark lead, such as a B or 2B, you need to be careful not to smudge the paper.

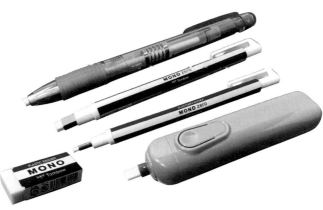

Erasers

As well as ordinary plastic erasers, you can also use a wide variety of erasers, such as pen-type erasers with a pointed tip, electric erasers, and kneaded erasers. Unlike pencils, colored pencils are difficult to completely erase, but erasers are essential items. You'll also be able to find some erasers in dollar stores.

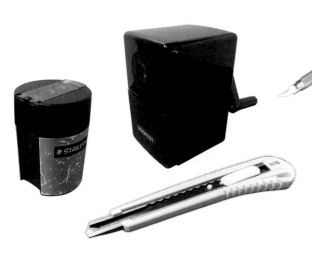

Designer Knives

The pen-type cutter is more suitable for detailed work than a cutter knife. You can use it for adding a highlight by erasing a color. (See page 11 for more details on color removal.)

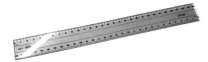

Rulers

Use for creating a grid to draw a rough sketch and to draw straight lines. Common ruler materials are plastic or steel, but you can use whatever you're comfortable with.

Pencil Sharpeners and Cutter Knives

There are many types of pencil sharpeners, from large desktop ones to smaller portable ones. The tip of the pencil (wooden shaft and lead) can be sharpened to an acute angle with some sharpeners and to an obtuse angle with others. The hardness of the lead of colored pencils varies according to the manufacturer, so you should choose a sharpener that suits the colored pencils that you're using. You can also sharpen the lead with a cutter knife.

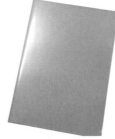

Anti-Sweat Underlay

When you're drawing with colored pencils, the sweat from your hands sometimes ends up on the paper. This is an underlay to prevent this. Slip the underlay between the paper and your hand that is holding the pencil. You can use things like a normal plastic underlay, tissue paper, or a plastic transparent file for this purpose.

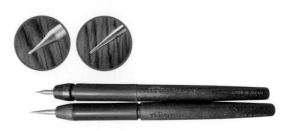

Styluses

A very important item for realistic colored-pencil drawing is a stylus. At first glance, they may look like a carpentry cone, but their tip is rounded rather than pointed like a needle. Use them like a pencil to indent the paper. You can also use a dot pencil or tracer instead. They both have different types of tips, so it's convenient to have several types at hand to provide the desired level of indentation. You can also use a ballpoint pen that has run out of ink, but beware of the risk of some residual ink coming out.

Dot Pens

A dot pen is used a lot in nail art. It has a rounded tip, so it can be used like a stylus. It can also be bought in a dollar store.

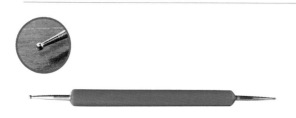

Pencils

They feel like pens and are used to indent dots and lines on paper. Recommended for fine highlighting and animal fur because the color does not cover indented areas. (See page 11 for more information on how to use a pencil.)

Tracers

Tracers are handicraft items. They are used to trace designs on Chaco paper. As they have a steel rounded tip like styluses, they can be used like them.

2 Basic Grips

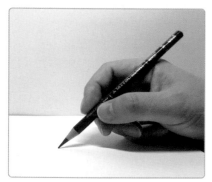

Basic

The common grip. As long as it allows you to control the pressure and move the pencil easily, you can use any grip that suits you.

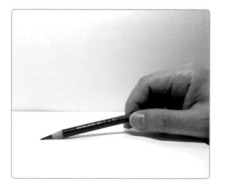

Horizontal

Hold the colored pencil high up the shaft and lower your hand so that the pencil lies almost horizontal to the paper. Hold a colored pencil like this when you want to apply a light coat of color or a smooth coat on a large surface.

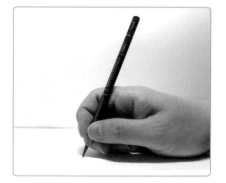

Upright

Hold the pencil low down the shaft near the lead, and tilt it into an almost-vertical position. This allows you to apply pressure, so it is suitable for strong and thick coloring.

3 Basic Coloring Method

Apply Vertically

Apply Horizontally

Apply Diagonally

Cross-hatching is a basic method of colored-pencil drawing. By applying the color vertically, horizontally, and diagonally (in this order) to the desired area, you can eliminate unevenness. The more you do this, the more even the color will be.

4 Color Shading

Light

Medium

Dark

Color shading is created by applying multiple layers of the basic coloring method, which is cross-hatching. If you want to apply colors lightly, use cross-hatching with light pressure for a smooth finish. If you want to apply colors more thickly, apply cross-hatching repeatedly and vigorously with firm pressure.

5 How Colors Look

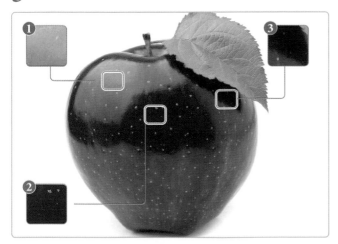

The important thing when drawing pictures is to observe the motif carefully. You can obtain a lot of information by observing things like where the light source is, how the shade is applied, and how the colors look. For example, look at the picture of the apple to the left.

1. The area exposed to the light is a pale, almost white, pink.
2. A darkish red, close to what's known as "madder red."
3. The shade of the leaf creates the darkest red, like a brown infused with purple.

So, if you look closely, you can see that an apple that looks only red actually contains elements of many different colors. You can bring out the depth of these colors by drawing the apple with colored pencils.

Color Mixing Basics (Three Primary Colors)

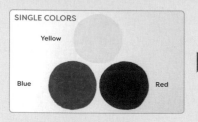

SINGLE COLORS

Yellow

Blue

Red

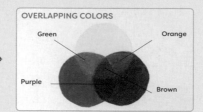

OVERLAPPING COLORS

Green

Orange

Purple

Brown

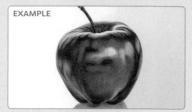

EXAMPLE

An apple drawn with just three colors.

Color mixing is one of the most basic techniques in colored-pencil drawing. With paint, colors are mixed on a palette. With colored pencils, colors are mixed by layering them directly on the paper. According to color theory, there are three primary colors (plus black) that can be mixed like printer ink to create any color. However, if you layer too many colors with colored pencils, the color may become dull or it may become impossible to apply the desired color, so pencils are available in many other colors than just the three primary colors and black. Try using lots of different colored pencils to create your own favorite colors.

6 Color Mixing Burnish

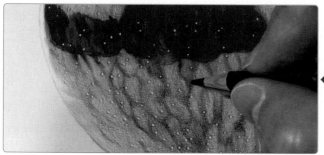

With Burnishing

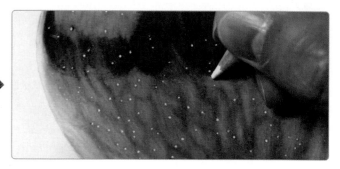

Without Burnishing

Burnishing is a technique for adding luster, or glossiness, to a colored surface. For example, if you apply a thin layer of a light color to the paper, the surface indentations in that area will appear when viewed up close. If you compare this to another area where the color has been thickly applied, you'll see a difference in the luster between the two areas. Use a light color, such as white, to create a strong layer over the thinly colored areas. By doing this, you can create a uniform luster and a blurring effect.

7 Color Mixing Grisaille Coloring

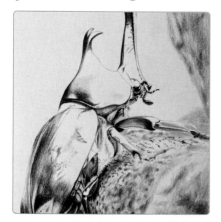

Grisaille Technique: Undercoat

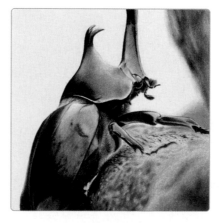

Grisaille Technique: Adding Colors

The grisaille* technique refers to a method of coloring in which only the shadows are drawn without any color to begin with, with the colors added on top later. This makes it easy to create a 3D effect and allows you to add colors without damaging the shading. However, the disadvantage is that the colors tend to become dull because they are mixed with gray shading. You should therefore only use this method after considering the suitability or unsuitability of the motif.

*Grisaille (gray) originally referred to paintings that were done in monochrome.

8 Depiction of Brightness How to Use a Stylus

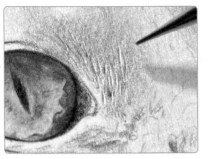

Carve Out Fur

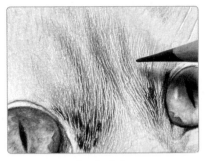

Apply Color

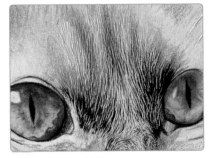

Add Patterns

As colored pencils are transparent, it's always going to be difficult to apply light colors over dark colors. This is why a stylus is used to depict small highlights or fine hair. First, apply a bright color, and then make indentations in it with a stylus. As no color can be applied to the indented area, you can depict fine details by coloring in the surrounding areas.

9 Depiction of Brightness How to Add Highlights

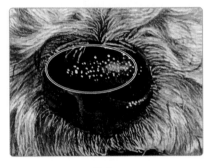

Stylus

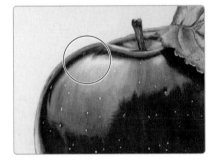

White Pencil

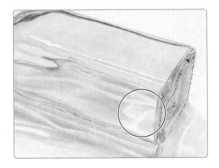

The Paper Itself

Highlights are the areas most exposed to light. The accurate depiction of such areas increases three-dimensionality and realism. There are various ways to add highlights, such as indenting the paper with a stylus, coloring with a white pencil, or using the white of the paper.

10 Depiction of Brightness Color Removal

Apply Blue → Yellow →
Reddish Purple → Black

Remove
the Top Surface

Reveal the Yellow
Layer Underneath

Mixing colors with colored pencils is like building up layers of color. By gently shaving the surface with a design knife, the colors of the lower layers can be brought out. The white of the paper can also be shaved away to reveal highlights. This technique is suitable for expressing details that are too fine to be drawn with colored pencils, such as the leaves on a tree. As the colored surface is being physically scraped, take care to avoid tearing the paper.

11 How to Draw Eyes

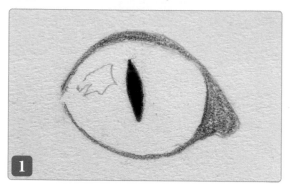

1

Color the pupil with thick black strokes by applying strong pencil pressure.

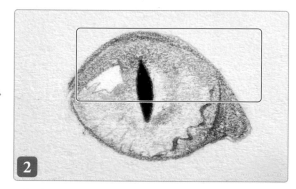

2

Color the iris area smoothly. Color in the top part, which will be in the shade, with thickish strokes of gray.

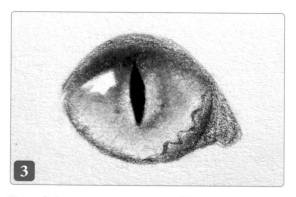

3

Using a little more pressure than in Step **2**, use a base color such as yellowish green or light blue to bring out the iris color more intensely.

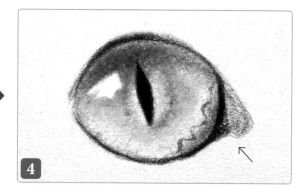

4

As the rim of the eye, which had been colored lightly beforehand, is now difficult to make out, apply strong pencil pressure in the upright position to color it black.

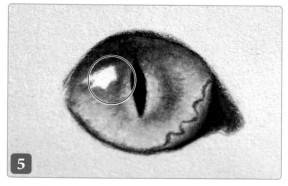

5

Apply more pressure and color the iris while eliminating unevenness. Take particular care to avoid coloring out the highlights in the circled area ◯.

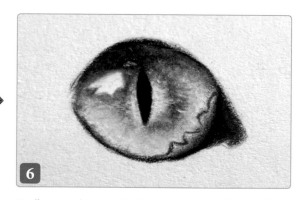

6

Finally, use a white pencil to firmly color out the blanks inside the highlights. Color out the highlights to the inside margins. By coloring even the subtlest highlights in the iris, you can create a more realistic and moister eye.

Drawing Photorealistic Colored-Pencil

PICTURES

Apple

 Drawn by Bonbon

Drawing Data

- **Rough Sketch:** One-half hour
- **Adding Colors + Finishing:** Eight hours
- **Pencil:** Staedtler Mars Lumograph HB

- **Colored Pencils:** Charisma Color
- **Colors:** 14
- **Paper:** Daigen Thick Kent Paper/A4

Color Data

Yellow PC916	(Canary yellow)	**White PC938**	(White)	**Green PC912**	(Apple green)
Red PC922	(Poppy red)	**Sky blue PC1023**	(Cloud blue)	**Dark Green PC908**	(Dark green)
Dark red PC925	(Crimson lake)	**Light purple PC956**	(Lilac)	**Gray PC1054**	(Warm gray 50%)
Pink PC929	(Pink)	**Brown PC947**	(Dark amber)	**Magenta PC930**	(Magenta)
Purple PC932	(Violet)	**Black PC935**	(Black)		

Artist's Note The basic color of the apple is red, but close observation of the motif reveals a slight yellow component. You should therefore start with yellow as the base color and then mix in the red later. There are also some complex colors in the shadows that the light cannot reach, so you can create depth by adding purple with bluish tints.

Original Image/Rough Sketch

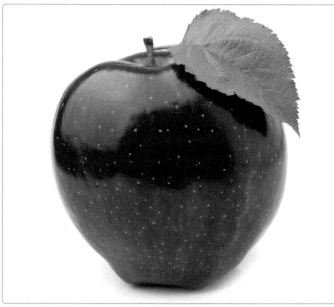

© Volosina/PIXTA

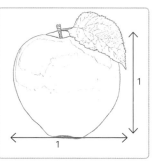

The three key points are
❶ Understand how the light and shadows work
❷ Correct use of the stylus
❸ Ensure a uniform surface luster
 For the rough sketch, take care to get the right overall balance with a rough vertical/horizontal ratio of 1:1. Try to capture as many surface irregularities as possible. When viewed from above, the apple assumes a pentagonal shape. The veins on the leaf should be depicted using a stylus, so it's okay to draw them first.

An apple is a perfect motif for an introductory drawing, as it has both a single color and a simple form. The simplicity of the object makes the effects of the light and shadows that they create very easy to observe, so it's ideal for an introduction to realistic drawing. It is packed with many basic techniques, so let's master them together.

Adding Colors

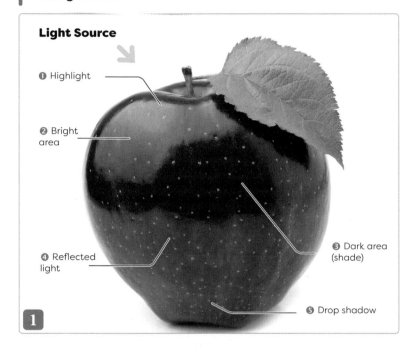

Light Source

❶ Highlight

❷ Bright area

❹ Reflected light

❸ Dark area (shade)

❺ Drop shadow

1

1 Understand the shadows

It's important to understand what sort of shade and shadows are created by the light hitting the apple. The brightest part is where the light directly hits the apple ❶. ❷ is where light also hits the apple. ❸ is the area that is difficult for the light to reach, otherwise known as the shade. ❹ is the area that is bright due to light reflected off a nearby object, in this case the floor. And ❺ is the darkest area where light has been blocked by the object, otherwise known as the shadow.

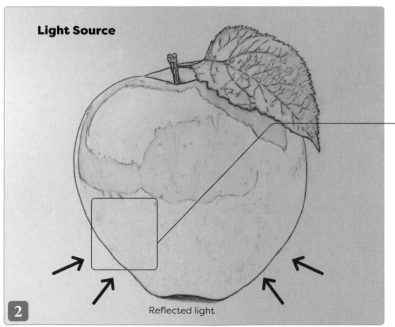

Light Source

Reflected light

2

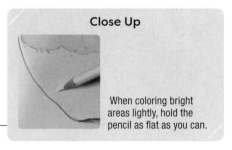

Close Up

When coloring bright areas lightly, hold the pencil as flat as you can.

2 Apply a yellow undercoat

The redness of the apple's skin contains a slight element of yellow, so you should use yellow as the base color. Observe the motifs carefully, and then create correctly modulated shadow and shade by lightly coloring the bright area ❷ and the area lit by reflected light ❹.

Yellow

Continues on next page ▶

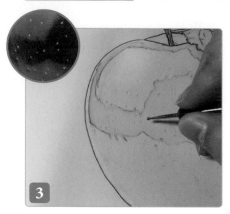

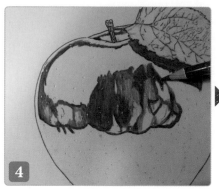

3 Carve out the fruit dots

Create some small indentations on the surface with a stylus to express fruit dots. Fruit dots (lenticels) are the dots on the surface of a piece of fruit's skin (top left inset).

4 Color all the skin with red

Depict the patterns on the surface of the skin with red. Also color the stem with the same color. Then color the whole apple lightly with red. In Step **4** and beyond, add color in the same way to all parts of the skin that need to be colored.

▬▬ Red

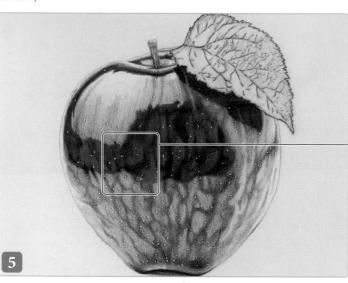

Close Up

Color so that the thickly colored areas connect with the patterns on the areas showing reflections.

5 Strengthen the shadows with dark red

First, color the thickly shaded areas and the patterns with dark red and then lightly color the whole apple with the same color while looking at the overall impression.

▬▬ Dark red

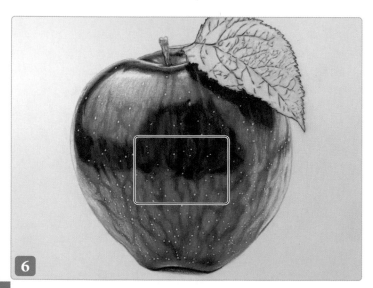

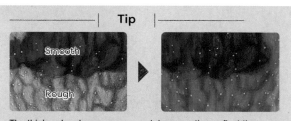

Tip

Smooth

Rough

The thinly colored areas seem rough because they reflect the unevenness of the paper. Apply burnishing to even out the luster.

6 Adjust the luster

Burnish with pink to even out the luster of the colored surface, focusing on the bright area (❷) and the lightly colored area lit by reflected light (❹). Apply strongly to blot out the color and blur the patterns.

▬▬ Pink

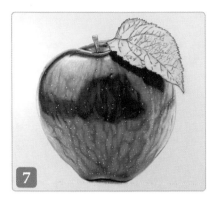

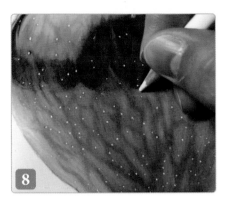

Tip

Light-colored leads (especially white) tend to get stained by other colors, so always try to have another sheet of paper nearby and wipe the lead as soon as it gets dirty.

7 Emphasize the shadow
Continuing from Step **6**, color the strongly shaded area and the heavily patterned area with purple.

██ Purple

8 Adjust the coloring of the bright area and the area lit by reflected light
Continuing from Step **7**, burnish the bright area (**❷**) and the lightly colored area lit by reflected light (**❹**) with white. Blur the boundaries, burnishing the boundaries between light and dark particularly strongly. Then color over with sky blue and light purple.

☐ White · ░░ Sky blue · ██ Light purple

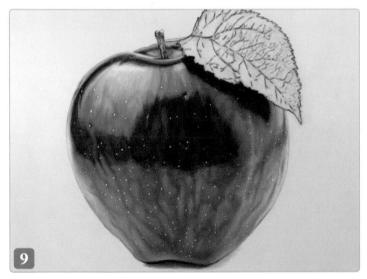

Tip

Think carefully about which fruit dots to add shadows to.

9 Strengthen the shadows even more
Continuing from Step **7**, strengthen the shadows even more with brown. Darkening the edge of some fruit dots will create three-dimensionality by expressing the depth of the holes.

██ Brown

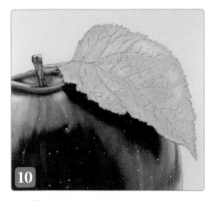

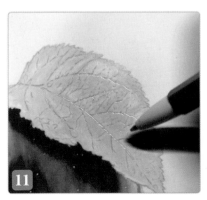

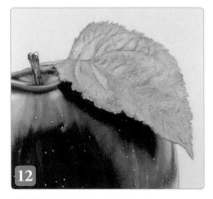

10 Color the bright parts of the leaf
Apply sky blue over the base color of yellow to create the color for the bright parts of the leaf.

░░ Sky blue

11 Carve the thick veins on the leaf
Express the main veins and the prominent lateral veins of the leaf by indenting them with a stylus. Do not carve the fine lateral veins at this stage.

12 Add shading to the leaf
Color the leaf with green to add shading. This will go well if you follow the veins that you carved out in Step **11** as a guide.

░░ Green

Continues on next page ▶

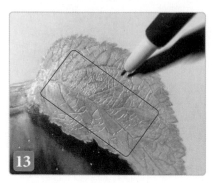

13 Carve out the fine leaf veins
Carve out the detailed leaf veins with a fine stylus. Create a natural differentiated atmosphere by using fine strokes within the red rectangle ▭ and thicker strokes outside it.

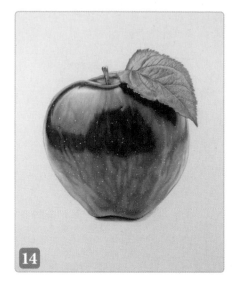

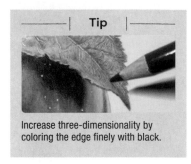

14 Further strengthen the shading on the leaf
Emphasize the shading contrasts with a richer deep green than in Step 12. The trick is to vary the coloring around the tip of the leaf and its veins.

■ **Deep green**

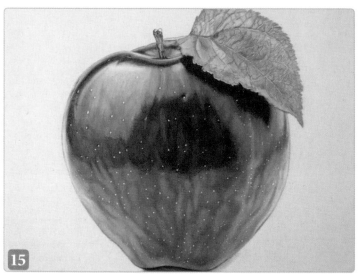

15 Recovering from mistakes
If the dark green was applied too evenly in Step 14, making the leaf look dry, you can use a pen eraser to lighten the color in the failed areas and re-shade them.

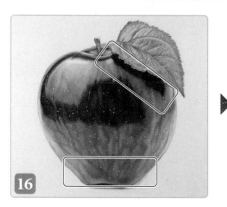

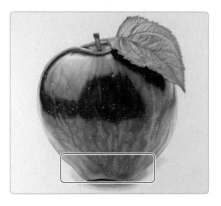

16 Color the shadows
Color the shadows created by the leaf and the apple in black, and then color the lighter areas of the shadows in gray. The shadow on the floor has a reddish color due to the reflection of the apple. This can be depicted by coloring over the shadow with pink.

■ **Black** · ■ **Gray** · ■ **Pink**

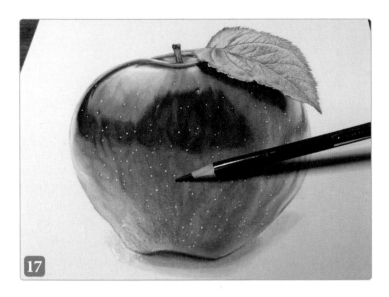

Tip

To make the veins on the leaf stand out, color the details with dark green.

17 **Finish with some final overall adjustments**
Make final adjustments after viewing the entire image as a whole. In this case, the apple lacked color in the bright area (❷) and the area lit by reflected light (❹), so I added a light coat of magenta to add depth to the colors. I also added dark green around the veins of the leaf to increase detail.

■ **Magenta** · ■ **Dark green**

Completion

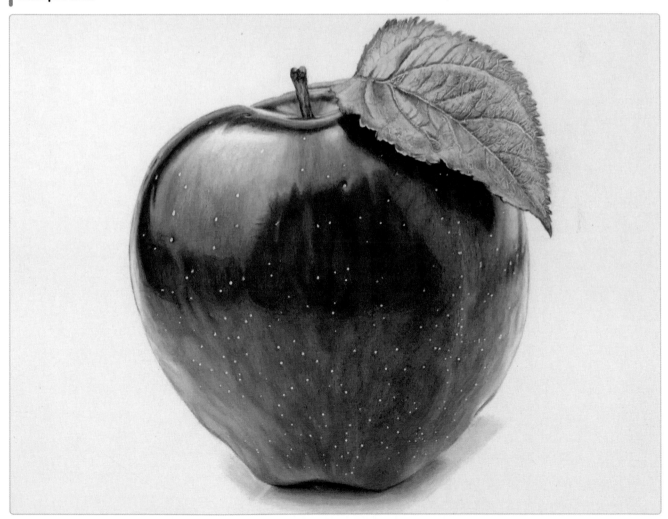

Continue to work on the drawing until there are no areas of concern left. Once you're happy with it, it's completed.

Green Grapes

 Drawn by Ryosuke Mika

Drawing Data

- **Rough Sketch:** Two hours
- **Adding Colors + Finishing:** 10 hours
- **Pencil:** Mitsubishi Hi-uni B
- **Colored Pencils:** Charisma Color
- **Colors:** Five
- **Paper:** KMK Kent Paper/B4 Large

Color Data

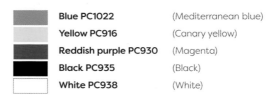

Blue PC1022	(Mediterranean blue)	
Yellow PC916	(Canary yellow)	
Reddish purple PC930	(Magenta)	
Black PC935	(Black)	
White PC938	(White)	

Artist's Note

Create the slightly dull green color of the grapes by mixing blue and yellow. Generate three-dimensionality by adding reddish purple and black.

Original Image/Rough Sketch

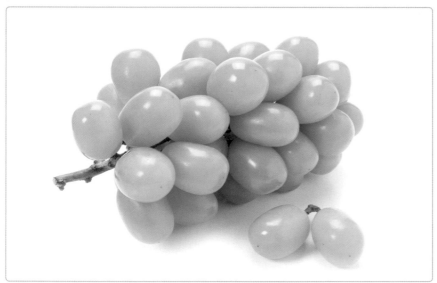

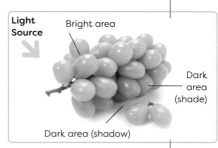

Light Source — Bright area — Dark area (shade)

Dark area (shadow)

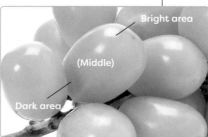

Bright area

(Middle)

Dark area

© Caito/PIXTA

The three key points are
❶ Bring out the three-dimensionality by properly capturing the light and dark
❷ Mix colors to avoid it become monochromatic
❸ Be aware of luster and other textures
 The grapes are not completely round, so observe their shape carefully when drawing the rough sketch.

Green grapes are the perfect motif for introductory drawing. They allow you to learn about basic shading and mixing colors. It is important to master these techniques to master photorealistic colored-pencil drawing.

Adding Colors

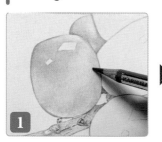

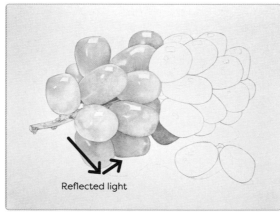

1 Color the bunch of grapes on the left side of the page

First, create light and shade with blue. As you will be adding yellow later, apply the blue gently and delicately. The trick is to color with the colored pencil lowered to a slightly horizontal position. You can convey the soft texture of the grape's skin by coloring carefully without leaving any visible pencil strokes. Depict the highlighted areas by leaving the whiteness of the paper uncovered. Don't forget to color the stem. Make the areas exposed to reflected light just a bit brighter.

▮ **Blue**

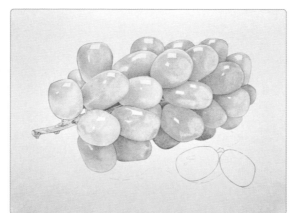

Reflected light

2 Color the bunch of grapes on the right side of the page

Color in the same way that you did in Step **1**, but create a greater sense of distance by making the back of the grape darker than the front side that's facing the light source. It is important to color with a strong awareness of light and dark. You should clearly define the lightness and darkness of not just the overall image but also of each individual grape. You should also color the two grapes in the lower right corner of the page.

▮ **Blue**

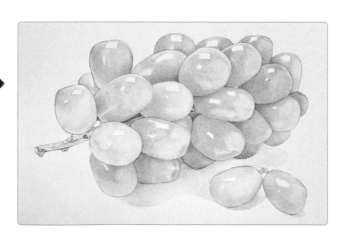

3 Apply blue for the shadows

The color of the grapes is also reflected in their drop shadows, so apply blue lightly for that effect.

▮ **Blue**

Continues on next page ▶

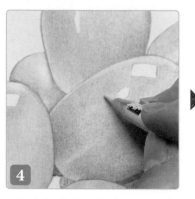 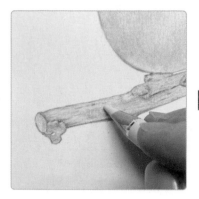 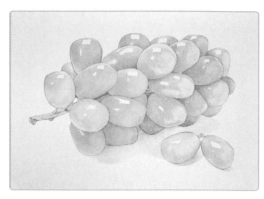

4 Color the bunch of grapes on the left side of the page

Add a layer of yellow. As it's difficult to add bright colors to an earlier coat, apply the color with strong pencil pressure at this stage. The trick is to add the yellow while holding the pencil in a slightly upright position. Even though you're coloring with quite a bit of pencil pressure, don't forget to do it carefully as well. Color the stem too.

Yellow

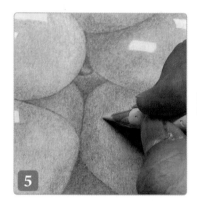 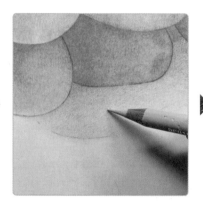 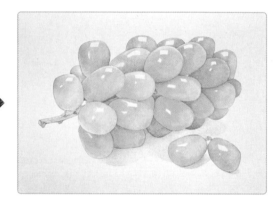

5 Color the bunch of grapes on the right side of the page

Color the grapes the same way as in Step 4, but make sure that you color not just the bright areas but also the dark areas. Also apply yellow lightly to the drop shadows.

Yellow

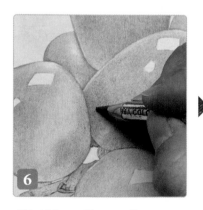 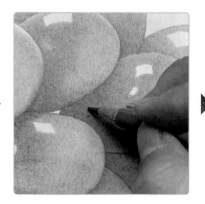 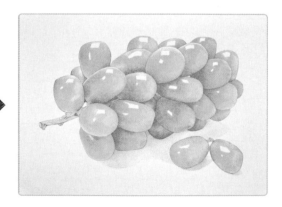

6 Add more blue overall

As there are still some areas that don't have enough blue, add some blue again, mainly to the dark areas.

Blue

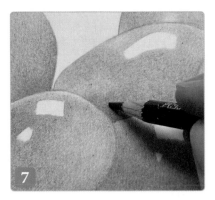

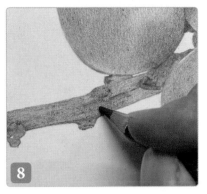

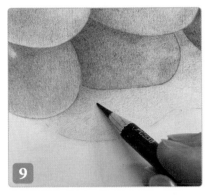

7 **Add the reddish purple to the dark area**
Green grapes also have reddish-purple areas, so lightly layer the dark areas with reddish purple.

▉ **Reddish purple**

8 **Color the stem reddish purple with strong pencil pressure**
Color the stem with reddish purple, applying quite a strong pencil pressure until it looks reddish overall.

▉ **Reddish purple**

9 **Color the drop shadows with reddish purple**
Also apply the reddish purple lightly to the drop shadow.

▉ **Reddish purple**

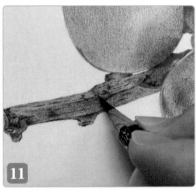

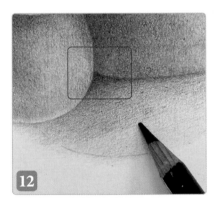

10 **Color the darkest areas**
Firmly apply black to the dark areas where the grapes overlap with each other.

▉ **Black**

11 **Color the stem's darkest area**
Color in the finest details of the stem's darkest areas with black.

▉ **Black**

12 **Color the drop shadows with black**
Apply black lightly to the drop shadow. The area where the green grape meets the floor should be colored a bit more thickly.

▉ **Black**

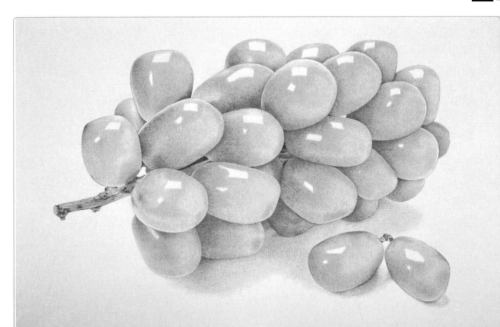

This is what the grapes looked like after I first applied blue and yellow, followed by reddish purple on the dark areas, and finally black on the darkest areas. I managed to convey three-dimensionality by bringing out the depth of the colors and clearly defining the light and the shade.

Continues on next page ▶

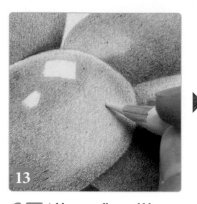 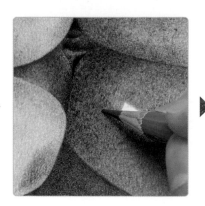 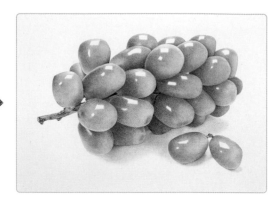

13 Add more yellow and blue

The inclusion of the reddish purple and black has diluted the greenness of the grapes, so you need to add yellow and blue again. The yellow may be a bit difficult to apply, so color with quite strong pencil pressure. The trick is to add yellow to the bright areas and blue to the dark areas.

☐ Yellow · ☐ Blue

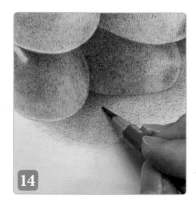 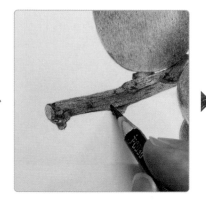 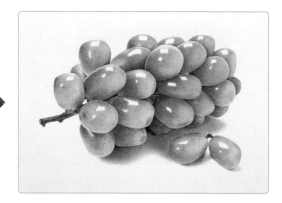

14 Add more color to the drop shadows and stem as well

Adjust the overall color by adding a bit of blue to the drop shadows and more reddish purple to the stem.

☐ Blue · ☐ Reddish purple

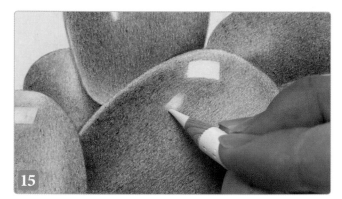

15 Add highlights

Once the overall color shading has been completed, use white to blur the highlights a bit.

☐ White

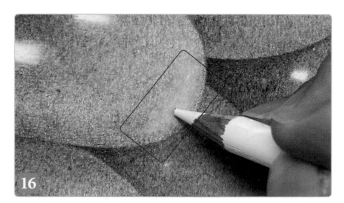

16 Create a glossy finish

To create a glossy finish, apply the white as if you are coloring out with it (see Burnishing Technique on page 10). There's no need to color the whole area, just the part where you want some luster to appear.

☐ White

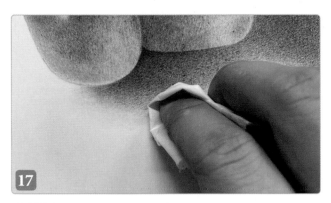

17 Blur using tissue paper
Blur the outline of the drop shadow by gently rubbing with tissue paper.

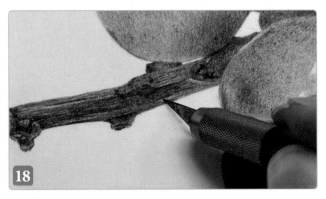

18 Remove color
Shave the colored surface of detailed areas of the stem with a designer's knife to create subtle shading. The trick is to hold the designer's knife in a slightly horizontal position.

Completion

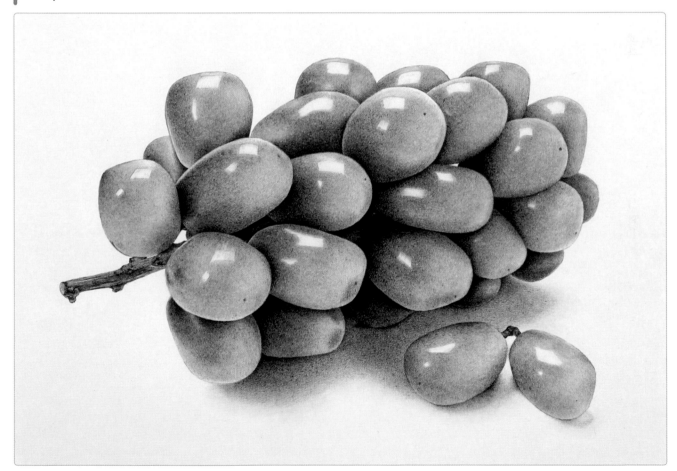

Stand back a bit to check the overall coloring and shading. If the areas where reflected light hits the grapes are too dark, you can brighten them a bit with an eraser. Once you're happy with the colors, it's finished.

Salmon Sushi

 Drawn by Miyakawa

Drawing Data

- **Rough Sketch:** One hour
- **Adding Colors + Finishing:** 10 hours
- **Sharp Pencil:** Staedtler Drafting Mechanical Pencil 925 0.3

- **Colored Pencils:** Mitsubishi Polycolor
- **Colors:** Seven
- **Paper:** KMK Kent Paper/A4

Color Data

- Orange: 4
- Yellow: 2
- Vermilion: 16
- Dark brown: 22

- Gray: 23
- Pink: 13
- Black: 24

Artist's Note The texture of the salmon is conveyed by orange and layers of yellow and vermilion. The light application of multiple colors for the rice as well turns it into a gastronomically convincing picture.

Original Image/Rough Sketch

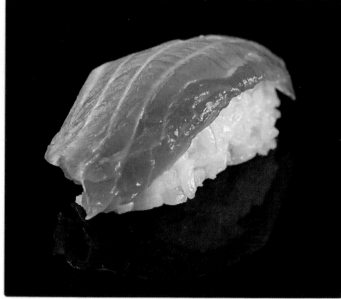

The three key points are
❶ Bring out the three-dimensionality by using color shading
❷ Mix colors to avoid them becoming monotonous
❸ Be aware of luster and other textures. In the rough sketch, draw five white stripes on the salmon and a highlight on its right side
 For the rice, draw the outlines of only a few of the grains in the foreground that are in focus and leave the rice at the rear shaded.

The key to making a food picture look real is to make the highlights stand out. The edge of the salmon and each grain should be highlighted in white. Once you have mastered this, you'll be able to create delicious drawings of other foods.

Adding Colors

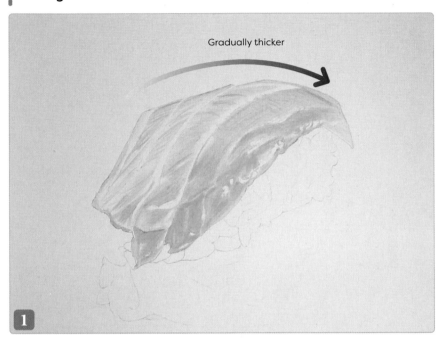

Gradually thicker

1

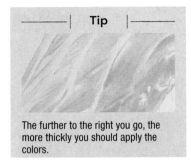

| Tip |

The further to the right you go, the more thickly you should apply the colors.

1 Color the whole piece of salmon with orange

First, color only the left side of the salmon orange, taking care to leave thick diagonal stripes of white. On the right side, color firmly with orange while also leaving white highlights along the side of the salmon. Ensure that the color gets thicker the further right you go.

▭ **Orange**

Close Up

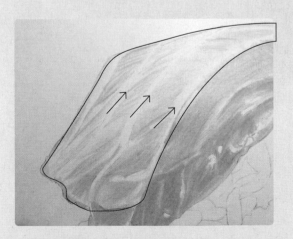

Pay close attention to the fine white stripes running through the flesh. Color them with several overlapping fine lines.

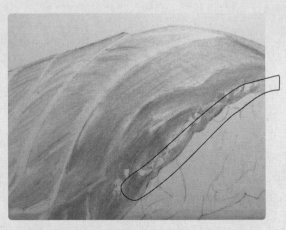

Be aware of the color shading while leaving white highlights.

Continues on next page ▶

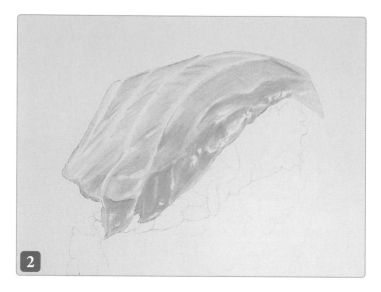

2 **Add a layer of yellow**
Apply a layer of yellow on top of the orange that you colored in Step ❶. Color two of the thick stripes on the right side of the page yellow as well.

Yellow

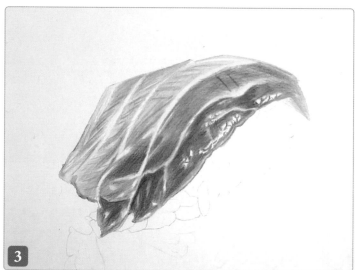

3 **Add a layer of vermilion**
On the lefthand side of the page, add several short lines of vermilion on top of the fine stripes that were colored in orange in Step ❶. On the righthand side of the page, color thickly with vermilion, leaving the thick stripes untouched. Ensure that the righthand side of the page gets darker at this stage as well.

Vermilion

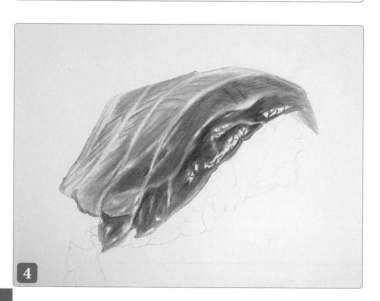

4 **Color the whole piece of salmon with orange**
Recolor from the top with orange. Color over the thick diagonal stripes. Ensure that the color on the righthand side of the page is thicker.

Orange

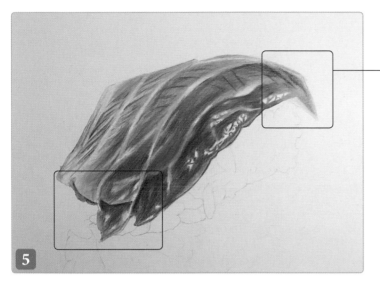

Close Up

Increase three-dimensionality by adding dark brown to some areas.

5 Apply dark brown to some areas
Emphasize the contrast by lightly applying dark brown to some areas of the front and the back of the salmon.

■ Dark brown

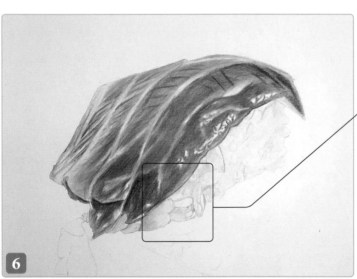

Close Up

Increase three-dimensionality by firmly delineating the grains of rice in the foreground of the screen.

6 Apply gray to the rice
Apply gray to certain areas of the rice to create highlights. Color the grains of rice in the foreground of the page individually, and only shade the rice at the back of the page.

■ Gray

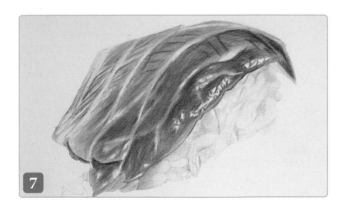

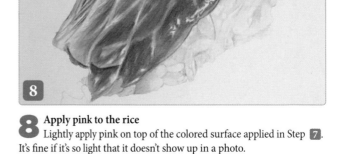

7 Apply yellow to the rice
Apply an extremely light layer of yellow on top of the colored surface applied in Step 6 . Take care not to color too thickly.

☐ Yellow

8 Apply pink to the rice
Lightly apply pink on top of the colored surface applied in Step 7 . It's fine if it's so light that it doesn't show up in a photo.

■ Pink

Continues on next page ▶

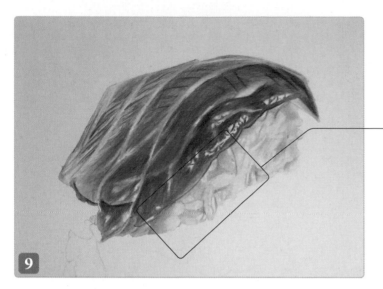

Close Up

By layering the colors, you increase how realistic the rice looks.

9 **Apply gray to the rice**
Emphasize the contrast by recoloring the areas colored in Step 6 with gray. The luster of the rice will stand out once you color enough to emphasize the highlights.

■ Gray

*This completes the drawing of the rice. Steps 10 and beyond are about applying a dark background.

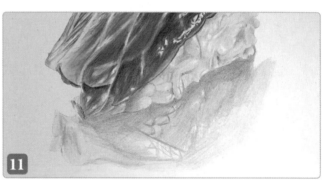

10 **Draw the reflection of the salmon**
Draw the reflection of the salmon. Lightly apply the salmon's orange. There's no need to draw too firmly, as you will be adding black later.

■ Orange

11 **Draw the reflection of the rice**
Lightly apply the rice's gray. The effect will be further enhanced by also adding gray to the rice itself. There's no need to color too firmly because you'll be adding black later.

■ Gray

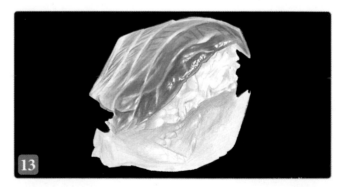

12 **Color the background evenly in black**
Start coloring the background. To prevent the picture of the sushi from getting smudged, rotate the paper so that the picture of the sushi is always on the opposite of the paper to your drawing hand. Use cross-hatching to reduce unevenness and produce a clean finish.

■ Black

13 **Color the whole background apart from the reflection in black**
Color the whole background evenly in black, leaving just the salmon sushi and its reflection. It's up to you whether you want to color right to the edges of the paper.

■ Black

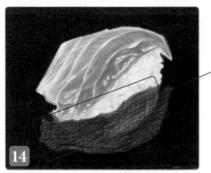

Close Up

By applying the black lightly, you'll blend it in with its surroundings.

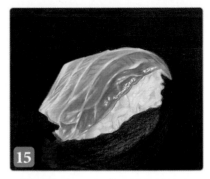

14 Color the reflection black
Color the sushi's reflection a bit lightly in black by holding the colored pencil in a low, almost-horizontal position. Repeat several times until the reflection becomes only faintly visible.

▇ Black

15 Recolor the reflected salmon in orange
Produce a beautiful orange reflection by coloring over the salmon's reflection with orange again. Then add some vermilion on top.

Orange ▇ · Vermilion ▇

Completion

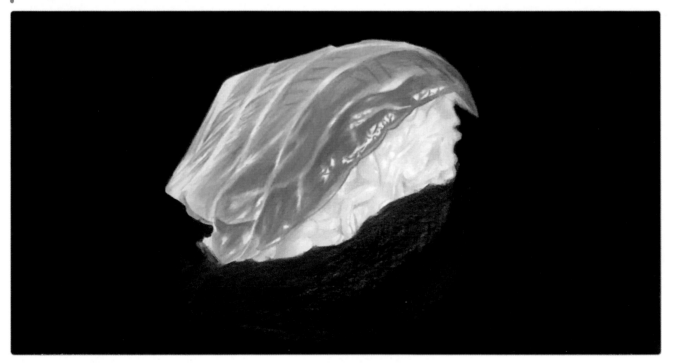

Adjust the shading of the reflections and the coloring of the background to complete the drawing. The solid black background glows when photographed, so you need to avoid direct exposure to the light when taking a photograph of the completed drawing. (See page 110 for more tips on taking photographs.)

Fruit Tart

 Drawing by Bonbon

Drawing Data

- **Rough Sketch:** One hour
- **Adding Colors + Finishing:** 20 hours
- **Sharp Pencil:** Staedtler Mars Lumograph HB

- **Colored Pencils:** Mitsubishi Uni
- **Colors:** 24
- **Paper:** Daigen Thick Kent Paper/A4

Color Data

Gray 623	(Seaside gray)	**Black 570**	(Black)	**Dark blue 529**	(Indigo)
Yellow 503	(Light yellow)	**White 501**	(White)	**Vermilion 508**	(Vermilion)
Yellow 505	(Yellow)	**Light green 549**	(Yellow green)	**Orange yellow 602**	(Orange yellow)
Mustard 551	(Mustard)	**Red 510**	(Geranium red)	**Brown 558**	(Cocoa)
Sky blue 532	(Sky blue)	**Dark red 511**	(Crimson red)	**Earthen yellow 552**	(Ochre)
Green 619	(Apple green)	**Reddish brown 608**	(Raspberry)	**Orange 507**	(Light vermilion)
Dark green 544	(Olive green)	**Pink 604**	(Rose pink)	**Dark gray 625**	(Stone gray)
Burnt umber 561	(Van Dyke brown)	**Cinnamon 605**	(Cinnamon)	**Light purple 521**	(Lilac)

Artist's Note Use many colors to depict the tart loaded with bright fruit. For each piece of fruit, you'll be using three to 10 colors, so color each one carefully to produce a realistic finish.

Original Image/Rough Sketch

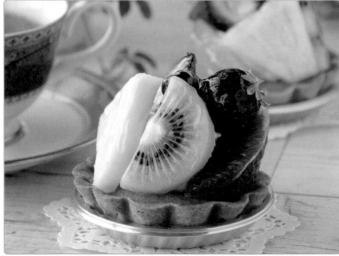

© shizuku/PIXTA

 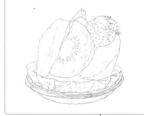

The three key points are

❶ Understand the characteristics of each fruit

❷ Make the fruit glisten by capturing its nappage (a fruit glaze created using gelatin)

❸ Convey the combination of softness and hardness using different coloring techniques

For the rough sketch, draw a well-balanced fruit topping for the tart. There's no need to draw with too much detail, but include distinctive areas, such as highlights and seeds.

A fruit tart laden with fruit is the motif. Because of the distinctive transparency of the pieces of fruit and the glaze created by gelatin, you'll be able to learn about various ways of expressing light, including highlights. This is great subject matter for practice, as you can draw different types of fruit in the one picture.

Adding Colors

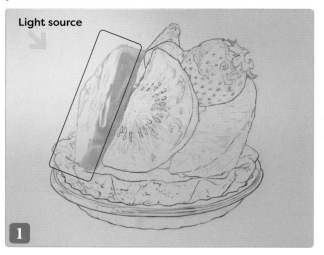

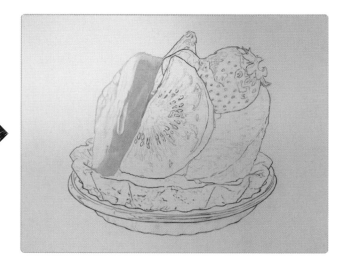

1 Color the pineapple
When coloring the shadow gray, don't color it evenly as some of the light goes through that area. You should therefore ensure that there's a good variety of light and shade. Don't forget that there are drops of gelatin dripping onto the shaded surface. When applying the light yellow on top of the gray, the surface of the pineapple directly exposed to the light is quite bright, so you should color lightly and use the white of the paper to express the undulations on the surface.

▨ Gray ·　　Light yellow

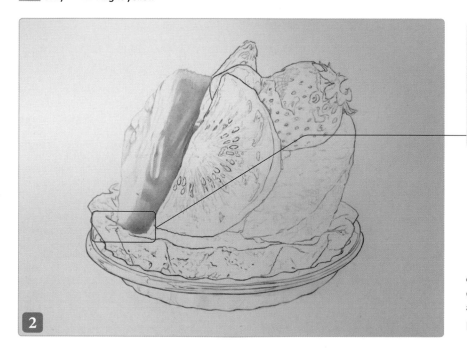

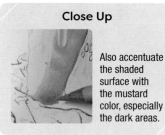

Close Up

Also accentuate the shaded surface with the mustard color, especially the dark areas.

2 Accentuate the shaded surface
Use yellow and mustard to accentuate the shaded surface.

Yellow ·　▨ Mustard

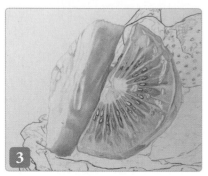

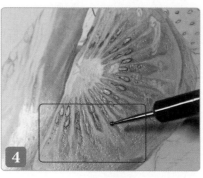

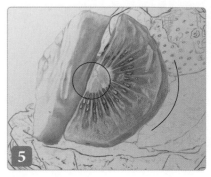

3 Color the kiwi

Apply sky blue to the whole of the kiwi as the undercoat. The locules (the areas where the seeds are) are dark, so color them thickly.

█ Sky blue

4 Create recessed highlights using a stylus

To express the fine highlights, carve them out with a stylus. The highlights are concentrated in the seeds and the locules, but there are also some highlights in the kiwi's skin that you should represent by carving out recesses in the area around the red rectangle ⬜.

5 Add other colors on top of the undercoat

Add a layer of yellow to the whole kiwi. Color the lower half quite strongly. Add mustard to the locules and the surface of the kiwi's side. Carve out recesses in the kiwi's skin around the red rectangle.

█ Light yellow · █ Mustard

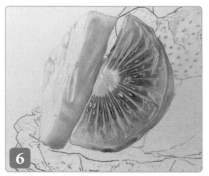

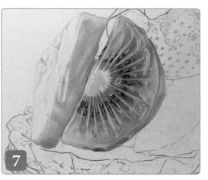

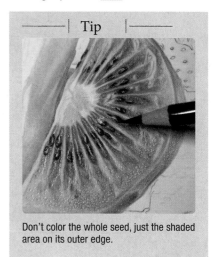

6 Adjust the coloring

Create some shine by adding a layer of green while leaving some areas of the base color untouched. You should also produce some depth by adding dark green to the locules.

█ Green · █ Dark green

7 Color the kiwi's seeds

Color the seeds burnt umber and then trace around their edges with black to create some three-dimensionality.

█ Burnt umber · █ Black

---| **Tip** |---

Don't color the whole seed, just the shaded area on its outer edge.

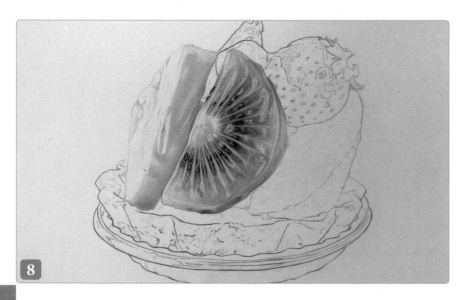

8 Finish the kiwi

Adjust the fruit's core with white and gray. Add light green as an accent to the pulp. Once colored, the kiwi is complete.

⬜ White · █ Gray · █ Light Green

9 **Color the strawberry**
As preparation for coloring its skin, hollow out the highlights with a stylus. After that, color the seeds and the stem with light yellow.

☐ **Light yellow**

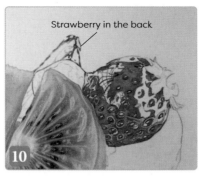

Strawberry in the back

10 **Color the strawberry's skin red**
The shading is complicated, so draw an outline and clearly define the boundaries of the different areas to be colored before you start coloring the whole strawberry. Color the strawberry behind it in the same way, but as it is not in clear focus; you can create some atmosphere by blurring it.

■ **Red**

| Tip |

Before coloring the whole thing, outline the boundaries between the different colors.

11 **Emphasize the shading**
For the shading, apply colors in this order: dark red, reddish brown, burnt umber. Clearly color the boundary between the strawberry and the kiwi.

■ **Dark red** · ■ **Reddish brown** ·
■ **Burnt umber**

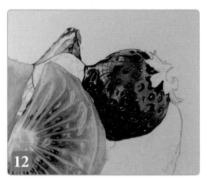

12 **Color the reflection of the light**
Color the reflection of the light with pink. Apply delicately and not too thickly.

■ **Pink**

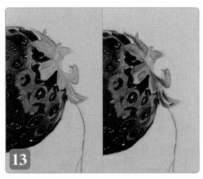

13 **Color the stem**
Add sky blue to the base color of light yellow. Then finish the stem by coloring the shaded areas in green and the darkest sections in dark green.

☐ **Sky blue** · ■ **Green** ·
■ **Dark green**

14 **Color the blueberry**
Although only partially visible behind the kiwi, it has fine patterned shading that you should color with dark blue while observing carefully.

■ **Dark blue**

15 **Color the rest of the blueberry with sky blue**
Color the areas of the blueberry that weren't colored in Step **14** with sky blue. Color with varying degrees of strength to convey the subtle shading caused by the light.

☐ **Sky blue**

16 **Color the reflections from other fruits**
The pieces of fruit on either side of the blueberry cast reflections, so you should convey that by applying light yellow to the left side marked ❶ and pink to the right side marked ❷. Complete this effect by adding black to the darkest areas.

☐ **Yellow** · ■ **Pink** · ■ **Black**

Continues on next page ▶

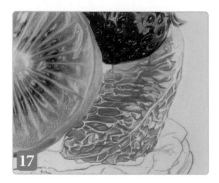

17 Color the grapefruit

Color the grapefruit skin first with vermilion, leaving thin white spaces for the stripes running across the segment.

■ Vermilion

18 Add gradations of shading

Add gradations of shading by adding dark red to the dark areas of the flesh. The trick is to emphasize the stripes in the flesh by adding dark red to the immediate areas beside them. The area denoted by the rectangle ▭ is particularly dark, so should be colored strongly with dark red.

■ Red · ■ Dark red

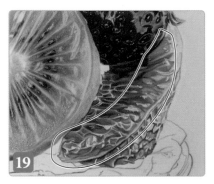

19 Add orange yellow to the bright areas

Add orange yellow to the bright areas in the skin (the area circled in the photo). Blend it well with the red base color.

■ Orange yellow

20 Color the remaining areas other than the highlights

Color the remaining areas other than the highlights with pink. In particular, color the lower half of the segment thickly.

■ Pink

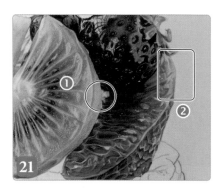

21 Finish the grapefruit

Complete the grapefruit by coloring the shadows cast by the strawberry and kiwi, adding shading in reddish brown and pink to ❶ and in cinnamon to ❷ .

■ Reddish brown · ■ Pink · ■ Cinnamon

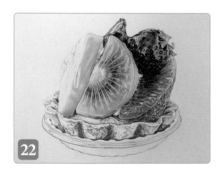

22 Color the tart

Color the shaded areas with brown and draw the prominent indentations on the tart's surface. Strengthen the shading on the fruit and the saucer with burnt umber.

■ Brown · ■ Burnt umber

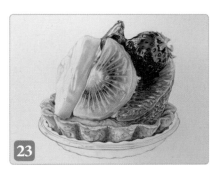

23 Color the whole tart with earthen yellow

Add a layer of earthen yellow to the tart. As it has a moist surface, create blur effects for the small indentations.

■ Earthen yellow

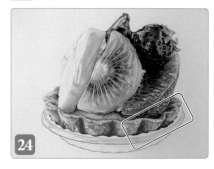

24 Add color to the tart

Color the tart with orange to add coloring. Also add yellow to the bright areas and dark red to the area denoted by the red rectangle.

■ Orange · ■ Yellow · ■ Dark red

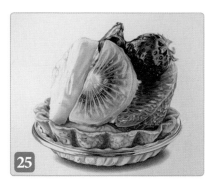

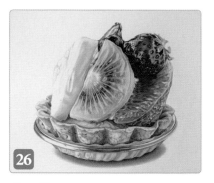

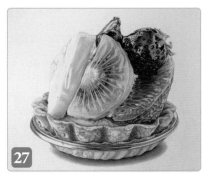

25 Color the saucer

Color the shading on the saucer with dark gray. Clearly define the variety in the shading to create a metallic effect. To create edges, color in the dark area with a sharpened pencil for a clean finish.

▬ Dark gray

26 Add color to the rim of the saucer

Add earthen yellow to the upper rim of the saucer. The bottom of the saucer reflects light from the floor, so add a layer of light purple to depict that. Also add light purple for the drop shadow created by the saucer on the floor.

▬ Earthen yellow · ▬ Light purple

27 Add the reflection on top of the saucer

The tart is reflected on the top of the saucer. Color the reflection of the shaded areas of the tart in brown.

▬ Brown

Completion

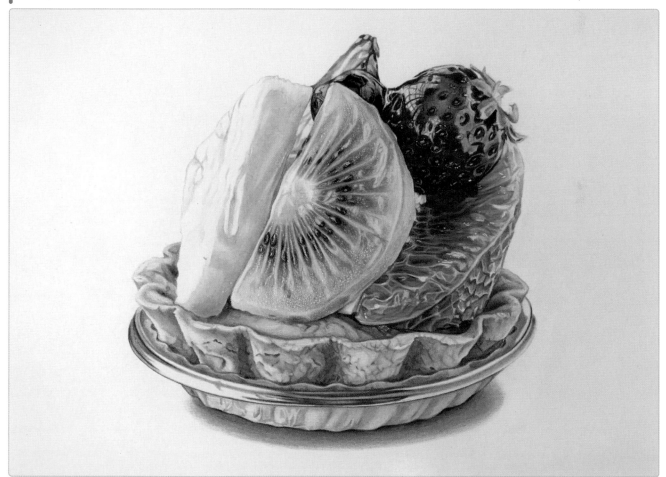

Complete the saucer by applying brown to the tart's reflection in the same way as in Step 27. If you're happy with the overall picture, your fruit tart is completed.

Gem

 Drawn by Miyakawa

Drawing Data

- **Rough Sketch:** Three hours
- **Adding Colors + Finishing:** 12 hours
- **Sharp Pencil:** Staedtler Drafting Mechanical Pencil 925 0.3

- **Colored Pencils:** Mitsubishi Polycolor
- **Colors:** Six
- **Paper:** KMK Kent Paper/A4

Color Data

Sky blue 8		Gray 23	
Blue 33		Turquoise 31	
Indigo Blue 10		Black 24	

 Artist's Note The key is how finely you can draw. Just imitate the step-by-step photos and try not to lose sight of where you are supposed to be coloring.

Original Image/Rough Sketch

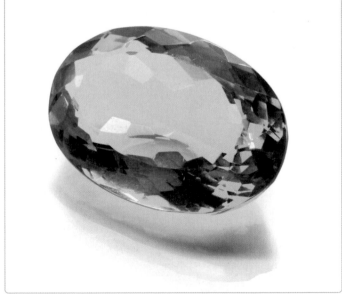

© lermannika/PIXTA

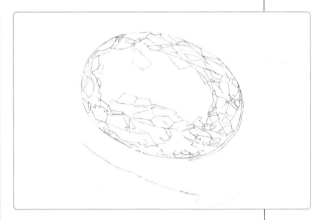

The three key points are
1. The linear patterns in the gem
2. Differences in coloring caused by the light
3. Oval-shaped exterior. In the rough sketch, draw the outline of the gem before drawing in the inside of the gem

The inside contains a lot of straight lines, so you can make it crisp and clear by using a ruler.

Gems can be an eye-catching work of art if you draw them beautifully. The shape may look simple, but it is extremely complex. So the sense of achievement that you get when you complete it will be unparalleled. Be patient and persevere!

Adding Colors

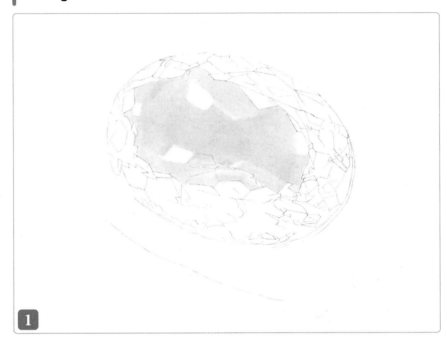

1

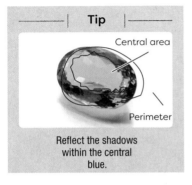

| Tip |

Central area

Perimeter

Reflect the shadows within the central blue.

1 Color the central part of the gem with sky blue
Color the evenly colored central part with sky blue while looking at the original image. Apply the color several times lightly, holding the sharpened colored pencil in a low, almost horizontal position. Use cross-hatching to remove any unevenness in the color. This will create a gemlike hard texture.

██ **Sky blue**

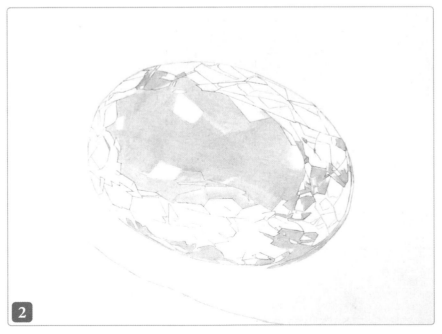

2

2 Color the perimeter with sky blue
Color the cut portion of the gem that has the same color as the central part of the gem in the same way that you did in Step **1**.

██ **Sky blue**

Continues on next page ▶

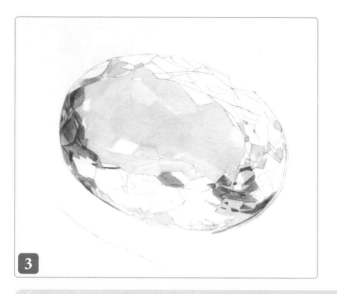

3

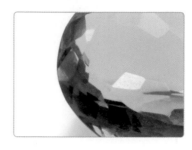

Draw each facet of
the gem one by one.

3 Color the light areas of the perimeter

Color the comparatively light areas of the gem's
perimeter with blue. Each facet has its own shading, so color
them in separately while looking carefully at each part.

■ **Blue**

Close Up

Each facet gets darker at one of its edges. Apply gradations
of shading by checking the original image to see which side
should be darker and which side should be lighter.

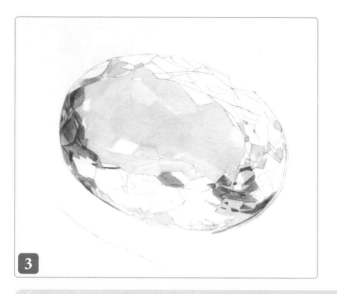

4

4 Color the slightly dark areas on the edge of the blue

Color the slightly dark areas of the edge of the blue that you
colored in Step **3** with indigo blue in the same way that you
did in Step **3**.

■ **Indigo Blue**

Close Up

Look at the photos in the Close Up of Step **3** and
check that you have colored the correct areas darkly.

5 Apply more colors in this order: gray, sky blue, blue

Reproduce the shading in each facet one by one, using gray. Then add an even layer of sky blue to change the coloring. Finally, add a light layer of blue on top. Repeat this process of gray, sky blue, blue in each facet. The gray shading is important, so keep looking at the step-by-step photos and the original image to check where you should color darkly and where you should color lightly.

■ Gray · ■ Sky blue · ■ Blue

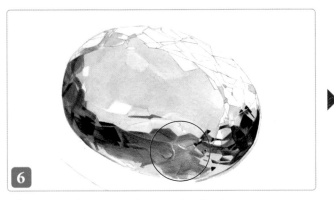
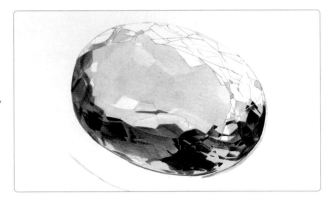

6 Color the facet beside the area colored in Step 5

Color the facet in the red circle beside the area that you colored in Step **5** with gray while looking at the shading. The amount of gray determines the shading, so you should follow that by evenly applying indigo blue.

■ Gray · ■ Indigo Blue

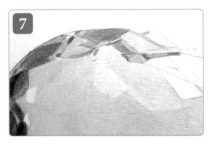
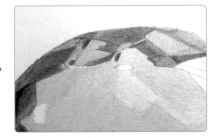

7 Color the top of the gem

Up until Step **6**, we have been using the same method. However, the top of a gemstone has more intense shading than the lower half, so be careful. First, apply the shading with gray and then add an even layer of sky blue. Then add blue, but do so thickly in the areas where the gray is thick, and lightly in the areas where the gray is light. Finally, add indigo blue intensively to the dark areas. The important thing is to look carefully at the shading of each individual facet that you're coloring.

■ Gray · ■ Sky blue ·
■ Blue · ■ Indigo Blue

Continues on next page ▶

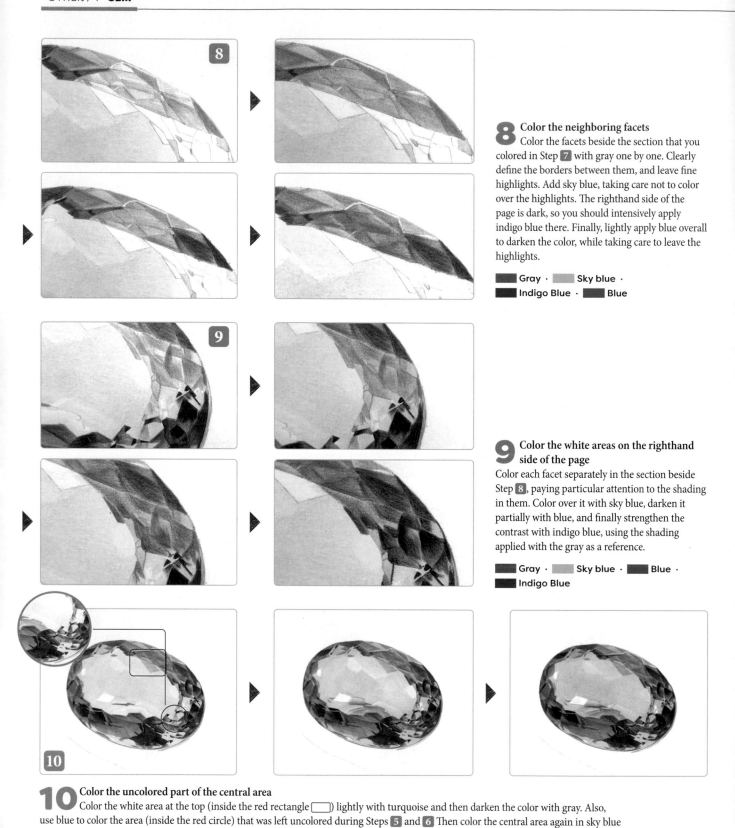

8 **Color the neighboring facets**

Color the facets beside the section that you colored in Step 7 with gray one by one. Clearly define the borders between them, and leave fine highlights. Add sky blue, taking care not to color over the highlights. The righthand side of the page is dark, so you should intensively apply indigo blue there. Finally, lightly apply blue overall to darken the color, while taking care to leave the highlights.

■ Gray · ■ Sky blue ·
■ Indigo Blue · ■ Blue

9 **Color the white areas on the righthand side of the page**

Color each facet separately in the section beside Step 8, paying particular attention to the shading in them. Color over it with sky blue, darken it partially with blue, and finally strengthen the contrast with indigo blue, using the shading applied with the gray as a reference.

■ Gray · ■ Sky blue · ■ Blue ·
■ Indigo Blue

10 **Color the uncolored part of the central area**

Color the white area at the top (inside the red rectangle ▭) lightly with turquoise and then darken the color with gray. Also, use blue to color the area (inside the red circle) that was left uncolored during Steps 5 and 6 Then color the central area again in sky blue and adjust the color by making it darker. Finish the gem itself by lightly applying more blue and turquoise.

■ Turquoise · ■ Gray · ■ Sky blue · ■ Blue

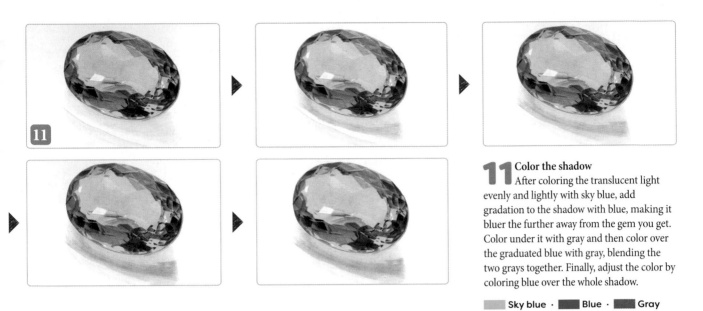

11 Color the shadow

After coloring the translucent light evenly and lightly with sky blue, add gradation to the shadow with blue, making it bluer the further away from the gem you get. Color under it with gray and then color over the graduated blue with gray, blending the two grays together. Finally, adjust the color by coloring blue over the whole shadow.

☐ Sky blue · ■ Blue · ■ Gray

Completion

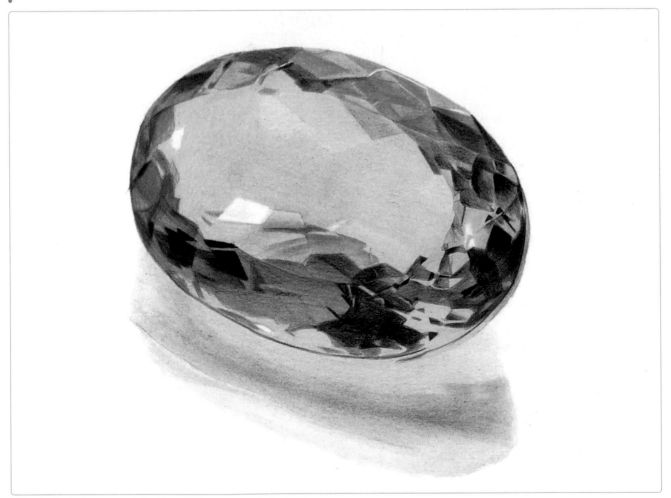

Make the final adjustments with white and black to compete the drawing.

Metal Rings

 Drawn by Ishikawa @ Colored Penci

Drawing Data

- **Rough Sketch:** One hour
- **Adding Colors + Finishing:** 16 hours
- **Pencil:** Mitsubishi Pencil uni

- **Colored Pencils:** Charisma Color
- **Colors:** 15
- **Paper:** White parchment paper/A4

Color Data

Cream PC914	(Cream)	
Beige PC997	(Beige)	
Dark cream PC940	(Sand)	
Bright gray PC1069	(French gray 20%)	
Bright brown PC941	(Light amber)	
Black PC935 (Black)	(Black)	
Burnt umber PC946	(Dark brown)	
Dark gray PC1074	(French gray 70%)	

Yellow PC916	(Canary yellow)
Earthen yellow PC1034	(Golden rod)
Gray PC1072	(French gray 50%)
Brown PC945	(Sienna brown)
Orange PC1003	(Spanish orange)
Sand PC940	(Sand)
Sky blue PC1024	(Blue slate)

Artist's Note Show the metal color using brown and yellow. Metal has high reflectivity, and it's the contrasts from the shading that provide its luster. The main order of applying color is: light color, dark color. For the shadows that create three-dimensionality, start first with bright gray and move gradually to dark gray. At the end, you'll have to decide whether to use black or not.

Original Image/Rough Sketch

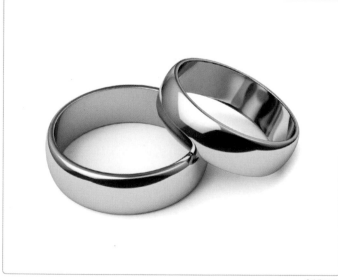

© deliormanli

The three key points are
❶ Express the metal
❷ Highlights and reflections
❸ The overlapping of the rings
 When drawing metal, the key point is how beautifully you can draw the highlights and the reflections. Leave the highlights in precisely the right place and be aware of the clear boundaries of the reflections when drawing. The surface of the rings is even, so try not to leave any visible pencil strokes.

Metal rings are one of the frequently used introductory motifs. They have a simple shape, clear reflections, a combination of colors, and need lots of techniques such as burnishing to convey their lustrous surfaces, so be careful and you will master them in no time.

Adding Colors

→ For this exercise, we'll draw the left ring first and then the right ring.

[Left ring]

1 **Apply the base color**
Apply the base color of cream to all areas other than the highlights.

Cream

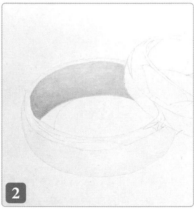

2 **Color the inside of the ring**
Apply first beige then dark cream, adding bright gray for the shadow.

Beige · Dark cream ·
Bright gray

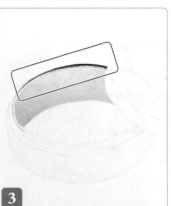

3 **Color the back edge of the ring**
Color the top edge at the back of the ring with bright brown, and emphasize the highlights by drawing the boundary with a curved black line.

Bright brown · Black

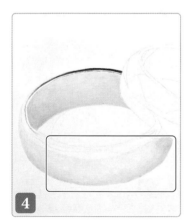

4 **Color the front side of the ring**
Lightly color the lower area of the front of the ring with beige, adding bright gray to bring out the three-dimensionality.

Beige · Bright gray

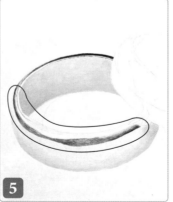 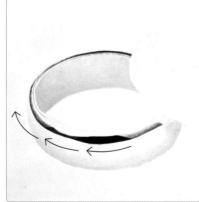

5 **Color the reflection on the front of the ring**
Color the reflection at the top of the front edge of the ring with cream and then bright brown. Color the boundary by starting right in the middle and applying black, burnt umber, and dark gray as you move to the left, all while following the rough sketch.

Cream · Bright brown · Black · Burnt umber · Dark gray

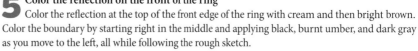

Continues on next page ▶

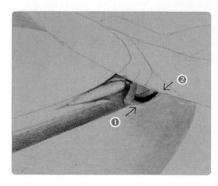

6 Color the area where the rings first overlap

Color the area lightly in yellow following the rough sketch. Then color around it in bright brown and then burnt umber, coloring both ends in black (the area denoted by the circle in the photo). After that, color ❶ in earthen yellow and ❷ in black.

Yellow · Bright brown · Burnt umber · Black · Earthen yellow

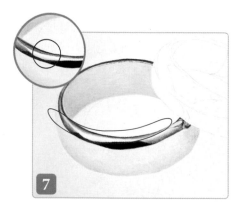

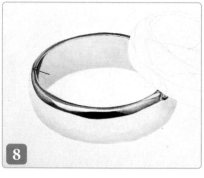

7 Color the inside of the front edge

Color in the order of: beige, bright brown, dark gray. The part inside the circle ◯ is the reflection of the electric light, and it should be lightly colored in beige.

Beige · Bright brown · Dark gray

8 Color the reflection on the back of the ring

As there's also a reflection on the left side of the back of the ring, you should apply burnt umber and then black there.

Burnt umber · Black

9 Color the shadow on the back of the ring

Color the area inside the circle ◯ with gray and then dark gray. Create three-dimensionality by coloring the ground side darkly and then more lightly the higher you go.

Gray · Dark gray

[Right ring]

Electric light

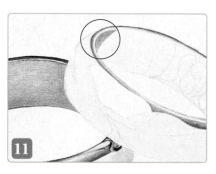

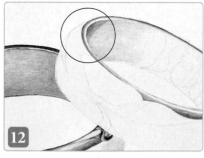

10 Apply the base color

Lightly apply cream as the base color for the ring on the right. Don't color the area where the electric light is reflected.

Cream

11 Color the upper edge

Color the upper edge with bright brown followed by bright gray. Color the circled area ◯ with earthen yellow.

Bright brown · Bright gray · Earthen yellow

12 Color the inner reflections on the back of the ring

Apply bright brown to the reflection on top of the rear edge that was colored in Step **11**, while carefully checking the original image.

Bright brown

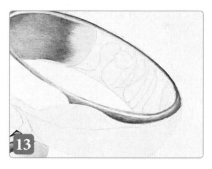

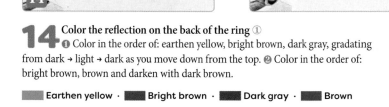

13 Color the shadow on the back of the ring

Color in the order of: gray, dark gray, earthen yellow, gradating the gray the further right you go.

■ **Bright gray** · ■ **Dark gray** · ■ **Earthen yellow**

14 Color the reflection on the back of the ring ①

❶ Color in the order of: earthen yellow, bright brown, dark gray, gradating from dark → light → dark as you move down from the top. ❷ Color in the order of: bright brown, brown and darken with dark brown.

■ **Earthen yellow** · ■ **Bright brown** · ■ **Dark gray** · ■ **Brown**

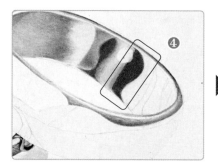

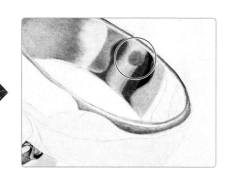

15 Color the reflection on the back of the ring ②

❸ Color in the order of: yellow, orange, bright gray, gradating the reflections on either side darkly and the center gradually lightly. ❹ Color with bright brown and strong pencil pressure, and then make it even darker by applying dark brown. There's a round reflection towards the top, so lightly draw a circle in black, erase it roundly with an electric eraser, color with bright gray, and then add more gray to it.

■ **Yellow** · ■ **Orange** · ■ **Bright brown** · ■ **Dark gray** · ■ **Black** · ■ **Bright gray** · ■ **Gray**

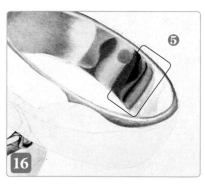

16 Color the reflection on the back of the ring ③

❺ Color with earthen yellow, and then darken by applying dark brown with strong pencil pressure to the reflections at both ends while looking at the original image. ❻ Color with bright gray and then beige. For the dark area, apply dark gray with strong pencil pressure. For ❼, first color with earthen yellow, followed by a linear application of burnt umber, bright gray, and bright brown.

■ **Earthen yellow** · ■ **Dark brown** · ■ **Bright gray** · ■ **Beige** · ■ **Dark gray** · ■ **Burnt umber** · ■ **Bright brown**

Continues on next page ▶

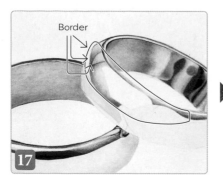
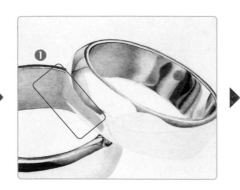
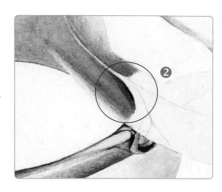

17 Color the reflection on the left side

For the reflection above the electric light reflection, apply bright brown, earthen yellow, and then color the reflection's shading by applying dark brown from the bottom up. Draw the boundary-like vertical lines in black. Color the reflection in ❶ with yellow and earthen yellow, and then create gradation by varying the pencil pressure with dark gray. Color ❷ with bright brown and then color the dark area with black.

■ **Bright brown** · ■ **Earthen yellow** · ■ **Dark brown** · ■ **Dark gray** · ■ **Black** · ■ **Yellow**

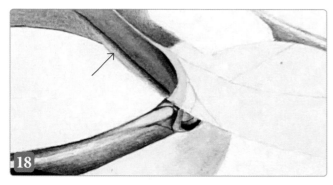
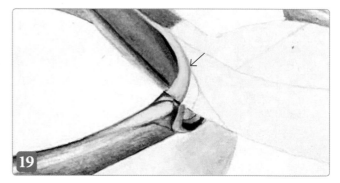

18 Color the bottom edge of the left side

Draw the boundary with black, earthen yellow, and yellow. Blur the black line a bit to make it look natural.

■ **Black** · ■ **Earthen yellow** · ■ **Yellow**

19 The front of where the rings overlap ❶

Color with yellow and strong pencil pressure, and color the boundary with earthen yellow as if drawing a line.

■ **Yellow** · ■ **Earthen yellow**

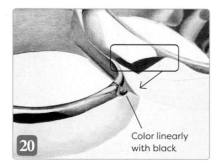
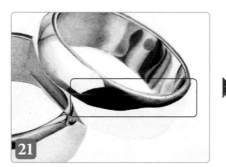
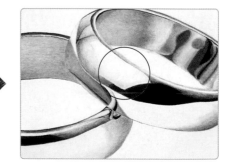

20 The front of where the rings overlap ❷

Color with earthen yellow and bright brown, and then add sand to the middle of the outline ☐. Color the area denoted by the rectangle with burnt umber.

Color linearly with black

■ **Earthen yellow** · ■ **Bright brown**
■ **Sand** · ■ **Black** · ■ **Burnt umber**

21 The front of where the rings overlap/Color the reflection of the electric light

Color the black area in the same way as in Step **5**. Color the reflected electric light, shown in the circle ◯, with a faint smudge of sand to leave a bright impression.

■ **Cream** · ■ **Bright brown** · ■ **Black** ·
■ **Burnt umber** · ■ **Dark gray** · ■ **Sand**

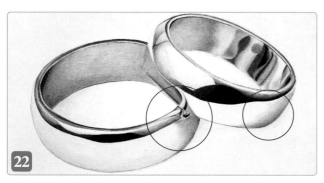

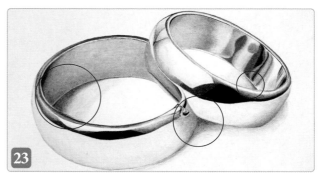

22 Color the shadows on the rings

Color the shadows on the rings, denoted by the two circles, with gray, and then darken with dark gray. Create three-dimensionality by coloring the edges thickly and then gradually more lightly as you go up the rings.

▬ Gray · ▬ Dark gray

23 Color the drop shadows

Decide the range of the drop shadows by looking at the original image, and then color lightly with sky blue. Add bright gray, gray, and dark gray to create depth, but don't forget to lighten the color the further away from the rings you get.

▬ Sky blue · ▬ Bright gray · ▬ Gray · ▬ Dark gray

Completion

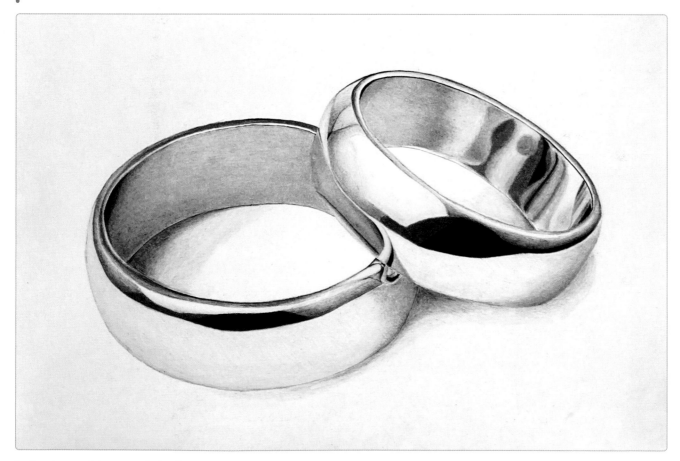

Look at the overall drawing and, if you're happy with it, it's complete.

Glass Bottle

 Drawn by Miyakawa

Drawing Data

- **Shooting the Photo + Rough Sketch:** Two hours
- **Adding Colors + Finishing:** 10 hours
- **Sharp Pencil:** Staedtler Drafting Mechanical Pencil 925 0.3
- **Colored Pencils:** Mitsubishi Polycolor
- **Colors:** Six
- **Paper:** KMK Kent Paper/A4

Color Data

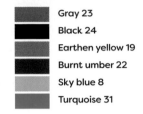

- Gray 23
- Black 24
- Earthen yellow 19
- Burnt umber 22
- Sky blue 8
- Turquoise 31

Creation of source image to be copied

Place a small glass bottle on an A4 piece of paper (297 mm x 210 mm) so that it doesn't stick out over the edges. Take the photo looking down on it diagonally. Ensure that the bottle's shadow fits onto the paper. Then transform the photo to A4 size using a smartphone app.

Artist's Note

At first glance, this drawing appears to be almost all gray. The key to realism is to catch the blueish and brownish tones that lightly color the glass.

Original Image/Rough Sketch

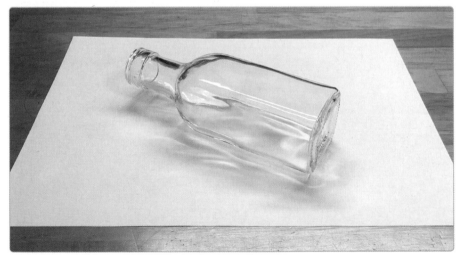

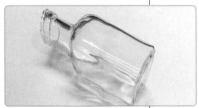

Photo after the transformation.

The three key points are
1. The glass bottle's translucency
2. Expression of the gas bottle's luster
3. The subtleties of the glass bottle's colored tints

Draw the bottle's outline and shadow using the photograph as a reference. Draw in detail the areas where the color changes, such as the highlights and the places where light is refracted.

This is the only trick artwork in this book. If you can skillfully draw the bottle with all its regular shading and light effects, it will look realistic. Lightly apply several layers of color to catch the light tints unique to glass bottles.

Adding Colors

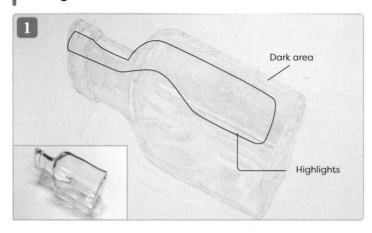

Dark area

Highlights

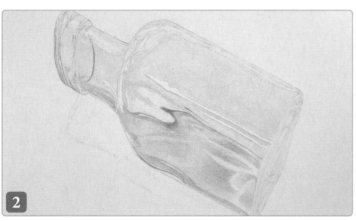

| Tip |

Depict the pattern in the slightly brighter area in the lower righthand corner of the original image by leaving it white at this stage.

1 Apply the base color
Overall, the bottle assumes a dim color, so you should apply the base color in gray. After Step **1**, you should regularly check your drawing by viewing it diagonally through a camera.

 Gray

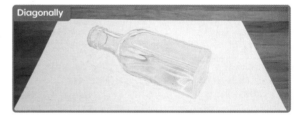

Diagonally

2 Emphasize the contrast
Emphasize the contrast, mainly at the bottle's opening and in the lower half of the drawing. Also color the ❶, ❷, and ❸ areas with black while holding the colored pencil in a low, almost horizontal position.

 Gray · Black

Close Up

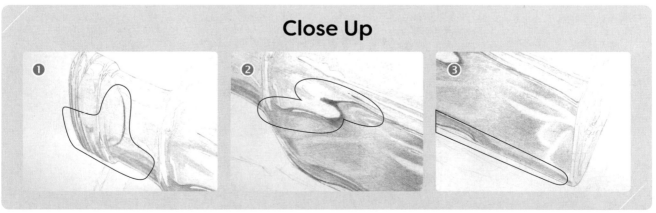

Continues on next page ▶

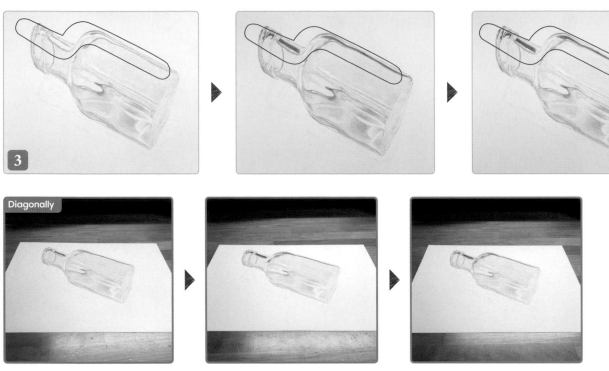

3 Add colors for the reflection from the desk ①

Color the area circled in red ▭ with earthen yellow while holding the colored pencil low in an almost-horizontal position (**1**). Then color the red rectangle ▭ with burnt umber and darken by applying black on top (**2**). After that, color the area circled in red ▭ with black, but thin it to the point that is only just darker than gray (**3**). Draw the fine pattern at the bottle's opening by holding the black colored pencil upright and sharply tracing the rough sketch. Finally, color the area circled in red ▭ with gray, and thickly apply sky blue on top (**4**). Leave the highlight at the bottom white.

▬ **Earthen yellow** · ▬ **Burn umber** · ▬ **Black** · ▬ **Gray** · ▬ **Sky blue**

Close Up

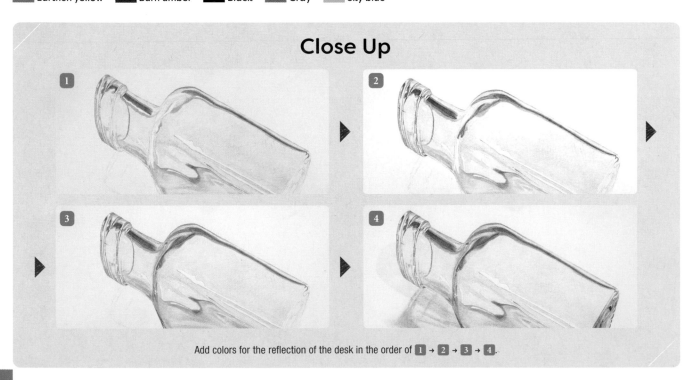

Add colors for the reflection of the desk in the order of **1** → **2** → **3** → **4**.

Close Up

In this case, I colored over the red area in the photo with a little gray.

4 **Add colors for the reflection from the desk ②**
Adjust the color of the area that was colored in Step **3**. Compare with the original image and correct the colors and colored areas that bother you.

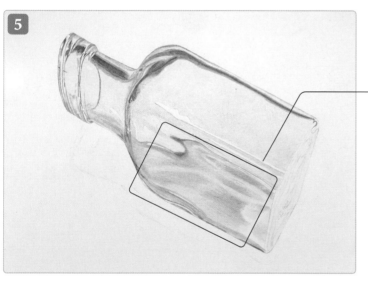

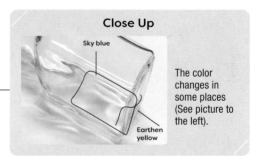

Close Up

Sky blue

Earthen yellow

The color changes in some places (See picture to the left).

5 **Add colors for the glass**
Color the bottom section of the bottle (the side touching the paper) with sky blue and earthen yellow colored pencils, holding them low in an almost-horizontal position. Apply the earthen yellow particularly lightly.

▬ **Sky blue** · ▬ **Earthen yellow**

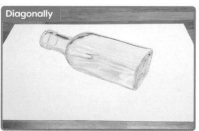

Diagonally

6 **Draw the bottom of the bottle**
Color the bottom of the bottle with gray, following the lines of the rough sketch. Color the shading in the middle of the bottom evenly while holding the pencil low in an almost-horizontal position, and depict the edge and fine lines sharply with the colored pencil in an upright position. Then color the reflection of the desk with burnt umber. After that, color the edge of the bottom by lightly applying sky blue and turquoise (because it's a bit greener than the sky blue on the side of the bottle). Finally, trace the edge and and fine lines with black.

▬ **Gray** · ▬ **Burnt umber** · ▬ **Sky blue** · ▬ **Turquoise** · ▬ **Black**

Continues on next page ▶

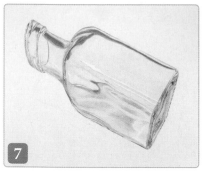

Close Up

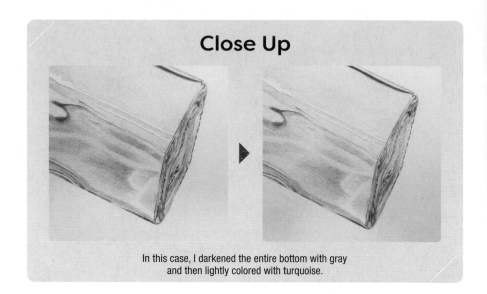

7 Adjusting the bottom of the bottle
Adjust the area that was depicted in Step 6. Compare with the original image and correct the colors and colored areas that bother you.

In this case, I darkened the entire bottom with gray and then lightly colored with turquoise.

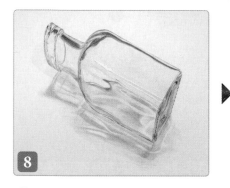

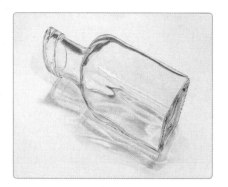

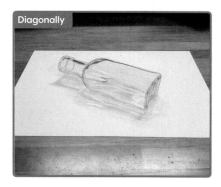

Diagonally

8 Draw the shadow ① ②
Shade with gray while carefully comparing it with the original image. The shadow falls along the side of the bottle, so be aware of the shape of it. The glass at the bottom of the bottle is thick, so you should color it thickly and leave the areas where the light is refracted white.

Gray

Close Up

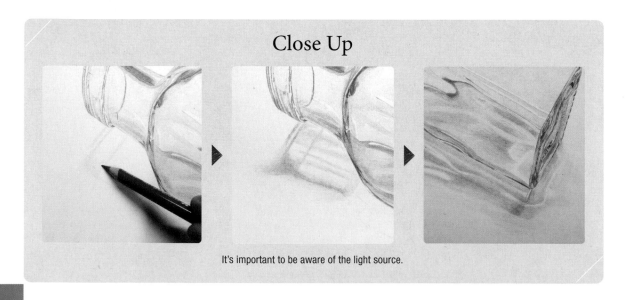

It's important to be aware of the light source.

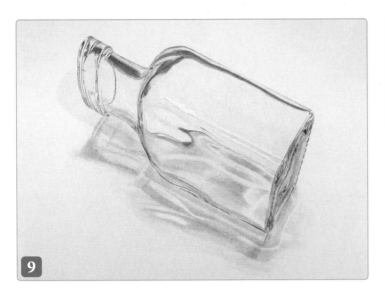

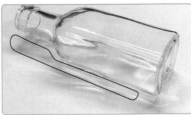

Be aware of the shape of the bottle.

9 **Draw the shadow** ②
Lightly color the shadow above the neck of the bottle and closest to the side of the bottle with sky blue. After that, look at the overall shadow and make fine adjustments. In this case, I slightly darkened the overall shadow with gray.

▨ **Sky blue** · ▨ **Gray**

Completion

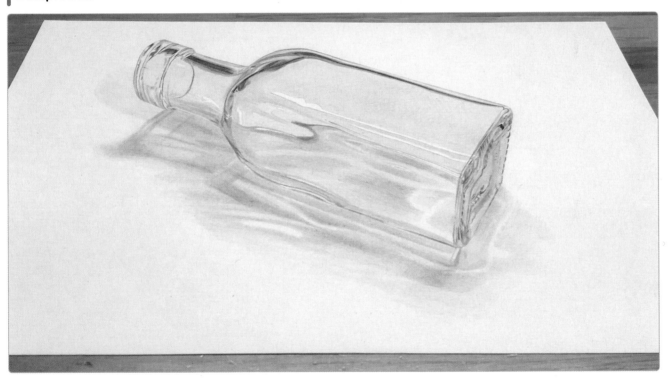

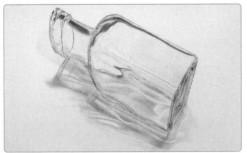

Look through the camera, take a photo at just the right angle, and you've completed your trick art. The photo on the left shows the finished drawing.

Beetle

 Drawn by Haru Otomi

Drawing Data

- **Rough Sketch:** 40 minutes
- **Adding Colors + Finishing:** Eight hours
- **Pencil:** Derwent Graphic

- **Colored Pencils:** Faber-Castell Polychromos
- **Colors:** Eight
- **Paper:** Daigen Thick Kent Paper/A4

Color Data

■	**Black 199**	(Black)
■	**Gray 271**	(Warm gray)
■	**Dark red 217**	(Middle cadmium red)
■	**Red 191**	(Pompeian red)

■	**Yellow 184**	(Dark Naples ochre)
■	**Earthen yellow 180**	(Raw umber)
■	**Orange 186**	(Terra cotta)
□	**White 101**	(White)

Artist's Note Beetles are not completely black but moderately reddish, so mix your colors while carefully observing the reddish color and the color of the shadows and highlights.

Original Image/Rough Sketch

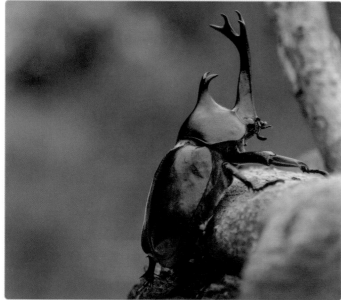

The three key points are
❶ Expression of surface luster and gloss
❷ Expression of the complexly colored fine hair
❸ Expression of detailed and complicated coloring with just a few colors
 For the rough sketch, copy the external appearance of the beetle properly and draw the highlights and other patterns that are on it. Also, copy the external appearance and patterns of the wood.

Beetles are suitable for practicing to create luster, subtle shadows, and various textures. You can express various textures, such as fur, smoothness, and roughness.

Adding Colors

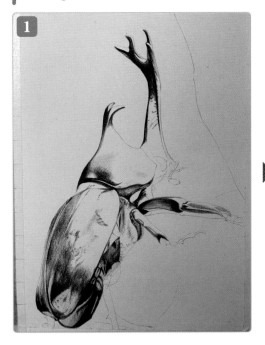

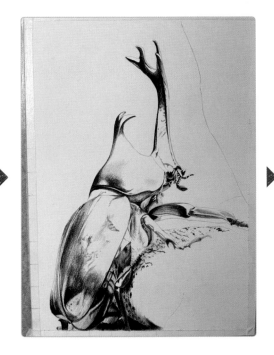

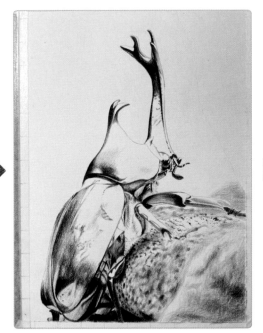

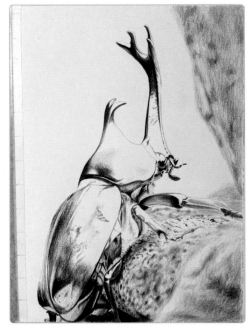

1 Add shading with different hues of black

Use black for the shading and to bring out the beetle's black colors and shadows. Don't color the highlights—refer to the original image for the different hues. At this point, using gray brings out the shadows more easily. For the branches, blur the out-of-focus branch in the foreground and the branch in the background by holding the colored pencil flat and applying little pressure.

■ **Black** · ■ **Gray**

Continues on next page ▶

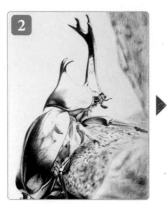
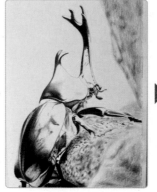
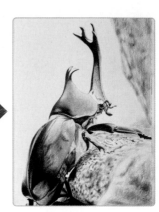

2 Color the head, thorax, wing, and legs

Color the head, thorax, wing, and legs with dark red, black, and red while looking at the original image. Color the dark areas with strong pencil pressure and the light areas with weak pressure, referring to the shading in Step **1** as a guide. After that, bring out the color by applying yellow faintly to the whole body while also expressing the slight highlights. The trick is to not apply too much pencil pressure.

Dark red · Black · Red · Yellow

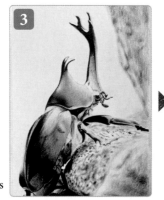
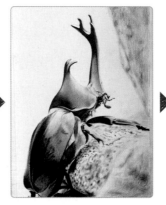
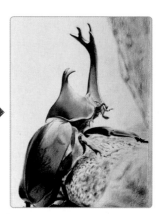

3 Reduce the brightness to bring out the darkness

The colors are too bright in Step **2**, so bring out the depth by applying gray everywhere with weak pencil pressure. In this case, I felt that the yellow was overall too strong, so I adjusted the color of the head, thorax, and wing with red.

Gray · Red

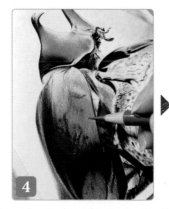
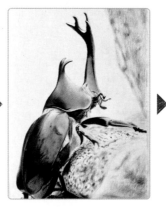
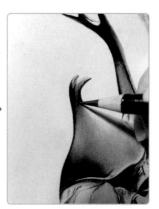

4 Express the wrinkles on the wing

Express the fine wrinkles on the wing by applying red and earthen yellow with strong and weak pencil pressure. Create depth by also adding orange to some areas. Color the horns on the thorax with the colored pencil in an upright position and draw the fine wrinkles with black.

Red · Earthen yellow · Orange · Black

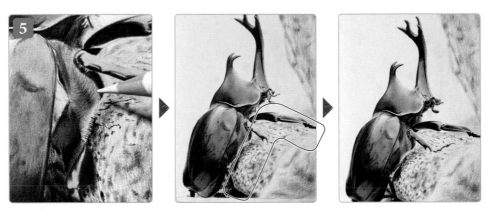

5 Color the hair

Color the hair on the abdomen with white, and then adjust the color by adding orange to prevent it becoming too orange. Color the hair on the legs in the same way. After that, adjust the overall color with red and gray. The trick is to color with a light pencil pressure. Color the back areas in the original image with black.

☐ **White** · ■ **Orange** · ■ **Red** · ■ **Gray** · ■ **Black**

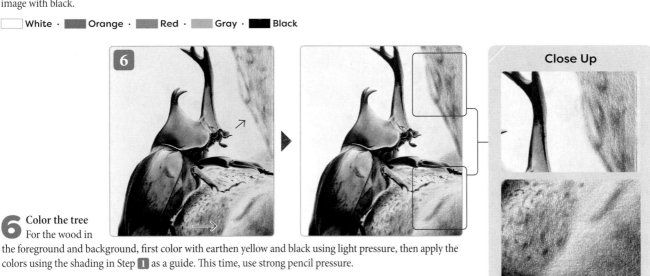

Close Up

6 Color the tree

For the wood in the foreground and background, first color with earthen yellow and black using light pressure, then apply the colors using the shading in Step 1 as a guide. This time, use strong pencil pressure.

■ **Earthen yellow** · ■ **Black**

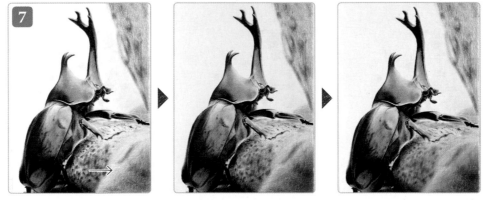

7 Bring out the texture of the wood in the foreground

Express the wood's texture by creating color gradation. Color the wood in the bottom left corner of the page with earthen yellow, starting thickly and then getting gradually lighter as you go further back. Add white to the lightly gradated area.

■ **Earthen yellow** · ☐ **White**

Continues on next page ▶

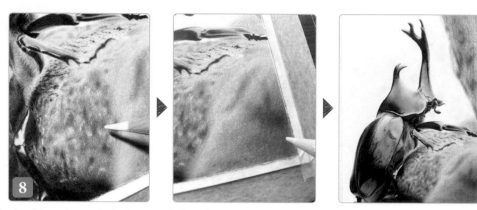

8 Draw the wood's highlights

Add highlights blurred by the white to the area in the foreground where the tree is in focus. The trick is to color with a well-sharpened pencil. After that, color the out-of-focus wood in the foreground. However, if you colored it with white, the color would be too light, so rub it with gray to eliminate any unevenness of color.

☐ White · ▨ Gray

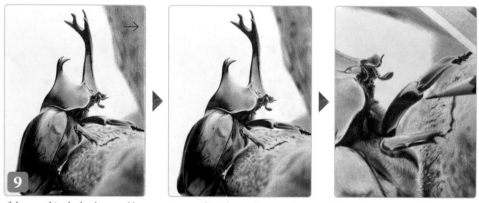

9 Bring out the texture of the wood in the background

Bring out the texture of the wood in the background by using gray and earthen yellow. Apply gray with quite a strong pencil pressure, and then add earthen yellow to the areas where you want to strengthen the wood color, topped with gray with lighter pencil pressure to create a blur effect. Correct the areas where the color of the wood overlaps with the beetle and the areas where edges and boundaries have become weaker and lost their clarity. In this case, I used a pencil, but you can also correct with a colored pencil with a similar color.

▨ Gray · ▧ Earthen yellow

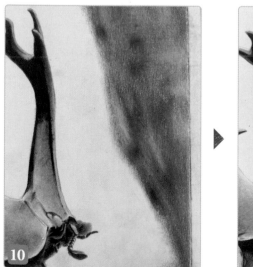

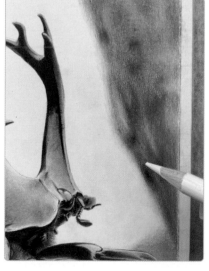

10 Color the outline of the wood

The wood's outline has been coarse up until Step 9, so blur it by applying gray with strong pencil pressure.

▨ Gray

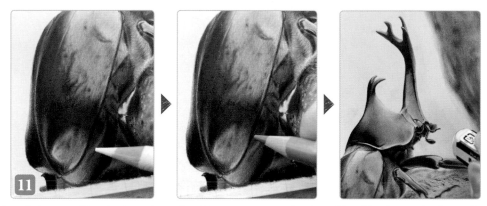

11 Rework the reflected light on the lower part of the wing

Rework the reflected light at the bottom of the wing by applying white. However, using just white by itself would make it too bright, so adjust the color by also adding orange. The trick is to be aware that the color of the wood is also reflected on the wing. After that, check that uncolored spaces haven't been smudged by any fine powder from the coloring process. Remove any smudges with an eraser.

☐ White · ▨ Orange

Completion

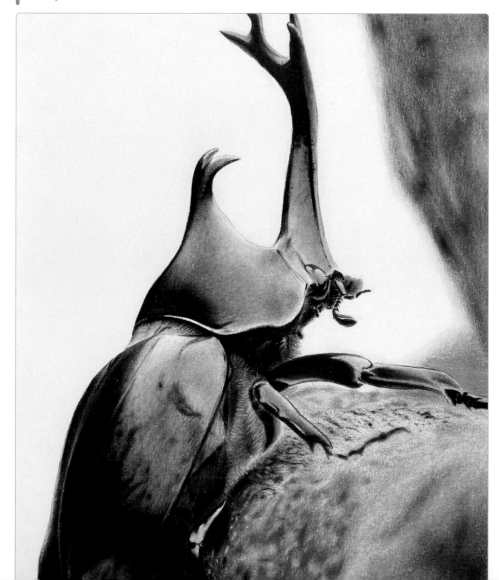

Stand back a bit and look at the picture. If you're happy with it, it's completed.

Parakeet

 Drawn by Ishikawa @ Colored Penci

Drawing Data

- **Rough Sketch:** One hour
- **Adding Colors + Finishing:** 18 hours
- **Pencil:** Mitsubishi Pencil uni 3H

- **Colored Pencils:** Charisma Color
- **Colors:** 16
- **Paper:** White Parchment Paper/A4

Color Data

	Black PC935	(Black)		**Light pink PC927**	(Light peach)	
	Gray PC1069	(French gray 20%)		**Pink PC928**	(Blush pink)	
	Cream PC914	(Cream)		**Reddish purple PC994**	(Processed red)	
	Yellow PC916	(Canary yellow)		**Light brown PC942**	(Yellow ochre)	
	Gray PC1072	(French gray 50%))		**Brown PC943**	(Burnt ochre)	
	Orange PC917	(Sunburst yellow)		**White PC938**	(White)	
	Blue PC902	(Ultramarine blue)		**Sky blue PC904**	(Light cerulean blue)	
	Pale blue PC1023	(Cloud blue)		**Orange yellow PC1012**	(Jasmine)	

Artist's Note The cream base color has the effect of preventing the other colors that are applied on top of it from sticking too much. It also helps convey the overall softness of the feathers.

Original Image/Rough Sketch

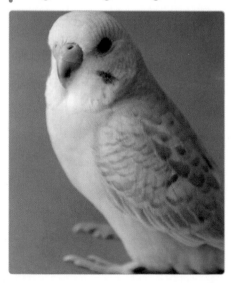

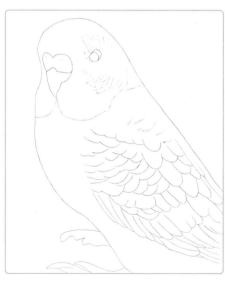

The three key points are
❶ Depiction of the body feathers
❷ Create three-dimensionality by adding shading
❸ Creation of complex coloring using many colors

For the rough sketch, it's important to copy the outline of the parakeet well and to also draw the patterns on the wing well.

Parakeets are one of the most popular bird motifs. This exercise is packed with information on how to draw feathers using a stylus, how to draw wings, and how to add a three-dimensional effect, all of which are necessary for drawing birds.

Adding Colors

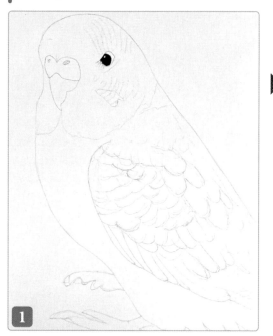

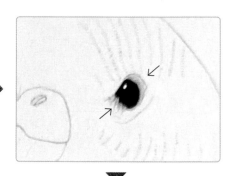

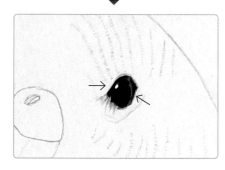

1 **Color the eye**
Draw the eye vigorously in black with strong pencil pressure, but leave the highlights. Next, color the area around the eye with light gray, and then adjust with black.

■ **Black** · ▨ **Light gray**

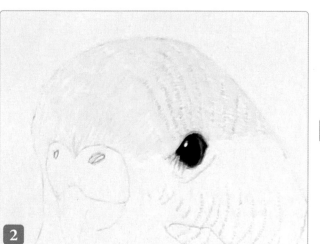

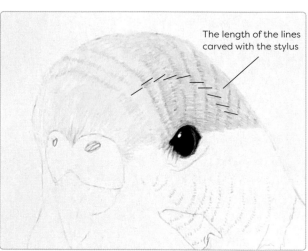

The length of the lines carved with the stylus

2 **Color the head**
Apply cream smoothly in the direction of the feather growth and then apply short lines of yellow on top to represent the feathers. After that, carve along the direction of the feather growth with a stylus and color the linear border of the feathers in gray.

Cream · ▨ **Yellow** · ▨ **Gray**

Continues on next page ▶

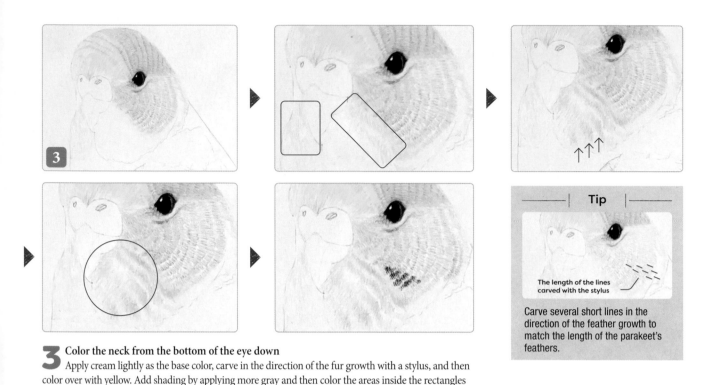

Tip

The length of the lines carved with the stylus

Carve several short lines in the direction of the feather growth to match the length of the parakeet's feathers.

3 Color the neck from the bottom of the eye down

Apply cream lightly as the base color, carve in the direction of the fur growth with a stylus, and then color over with yellow. Add shading by applying more gray and then color the areas inside the rectangles ▭ with yellow. Add a shadow around the bottom of the area inside the circle ◯ by lightly coloring it with light gray, and then apply shading by coloring yellow over it. Add some blue to the feathers.

Cream · Yellow · Gray · Light gray · Blue

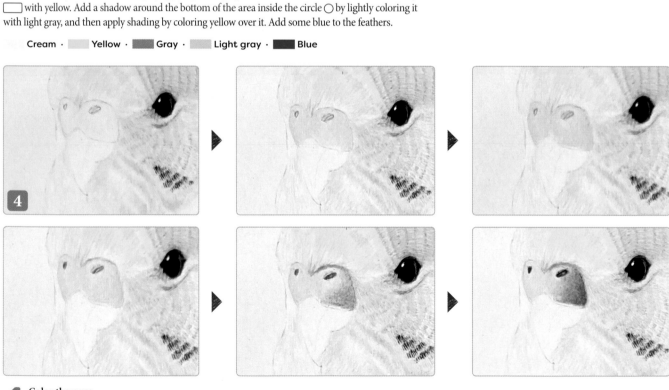

4 Color the nose

Apply light sky blue faintly as the base color, add a layer of light pink, and then bring out the depth by applying pink on top. Color the nostrils of the nose with orange, and create three-dimensionality by coloring the center of the right nostril with gray. Then add reddish purple to emphasize the shading and further enhance the three-dimensionality.

Light sky blue · Light pink · Pink · Orange · Gray · Reddish purple

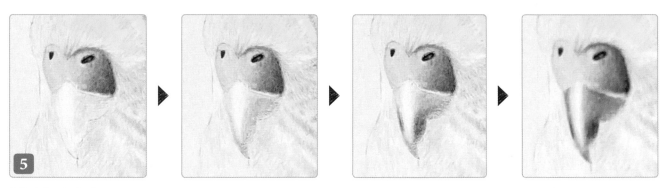

5 Color the beak

Apply pink lightly as the base color, taking care to leave the highlights untouched. After carving the scratches and texture of the beak with a stylus, apply light brown, and then add brown on top for shading. Look carefully at the original image when applying the shading. Finally, create three-dimensionality and depth by applying gray to the boundary lines with the nose, the edge on the left side of the page, and the tip of the beak.

Pink · Light brown · Brown · Gray

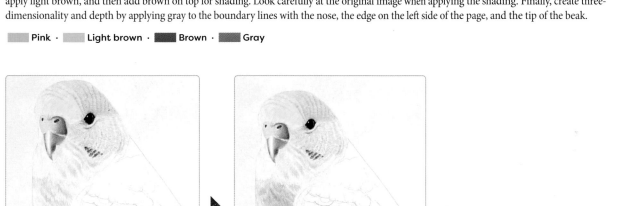

6 Color the stomach

Apply white smoothly as the stomach's base color, and overlay with short lines of sky blue. The trick is to keep the lines short and apply shading to depict the feathers. Repeat this all over the stomach.

White · Sky blue

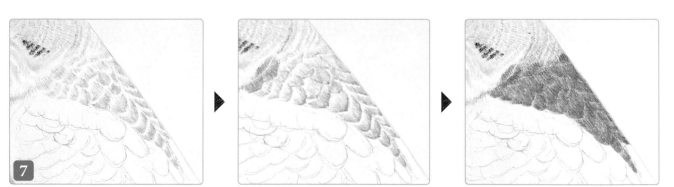

7 Color the back

Color the area from the neck down the back in the same way as Step 6. The trick is to leave the boundaries untouched to represent the feathers. Apply shading by coloring the boundaries with gray quite thickly, and then color the entire area with sky blue in a linear pattern with strong pencil pressure to create feathers.

White · Sky blue · Gray

Continues on next page ▶

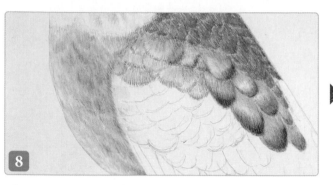

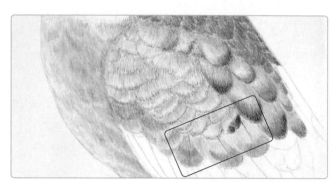

8 Color the wing ①

Color the feathers faintly one at a time with light sky blue, adding gray quite thickly to their boundaries, and then layering with sky blue with a strong pencil pressure (**a**). After repeating this, color the yellow-only parts with yellow while looking at the lower area of the wing in the original image, color the green parts of the area denoted by the rectangle ☐ using the same pattern from **a**, and then overlay with yellow to create green.

▇ Light sky blue · ▇ Gray · ▇ Sky blue · ▇ Yellow

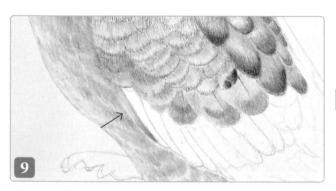

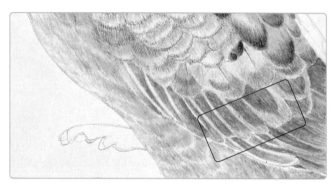

9 Color the wing ②

For the area of the wing right in the middle of the page, create a color gradation by first coloring the bottom section thickly with gray and then making it gradually lighter the higher up you go, all the while looking at the original image.

▇ Gray · ▢ White · ▇ Yellow · ▇ Sky blue

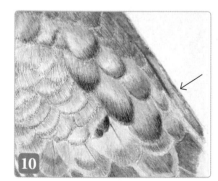

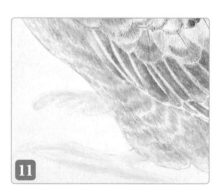

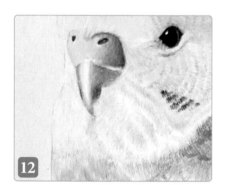

10 Color part of the back

Color with light orange, and then darken by adding gray with strong pencil pressure.

▇ Light orange · ▇ Gray

11 Color the legs

Color smoothly with white as the base color and then create three-dimensionality by coloring with light pink and a strong pencil pressure.

▢ White · ▇ Light pink

12 Color the shadow around the tip of the beak

Carve the fur around the tip of the beak with a stylus and then add shadow of the feathers with light gray.

▇ Light gray

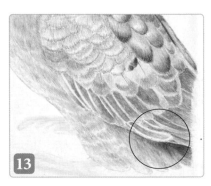

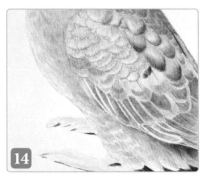

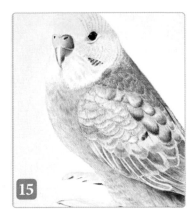

13 **Color the shadow of the wing**
For the shadow of the wing in the area inside the circle ◯, create three-dimensionality by coloring with gray and black while looking at the overall drawing.

 Gray · ▬▬ Black

14 **Color the drop shadow**
After coloring the drop shadow on the wood by thickly applying white, gray, and black, burnish (❯ page 10) from the top down with white and erase any signs of pencil strokes.

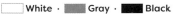 White · ▬ Gray · ▬ Black

15 **Adjust**
Adjust the overall coloring.

Completion

When I looked the whole drawing, I felt that it lacked three-dimensionality, so I darkened the shadows on the face and back with a pencil and added blue to the fur on the stomach.

Puppy

 Drawn by Bonbon

Drawing Data

- **Rough Sketch:** Two hours
- **Adding Colors + Finishing:** 40 hours
- **Pencil:** Staedtler Mars Lumograph HB

- **Colored Pencils:** Faber-Castell Polychromos
- **Colors:** 13
- **Paper:** Daigen Thick White Kent Paper/A4

Color Data

Light gray PC1069	(French gray 20%)	
Black PC935	(Black)	
Turquoise PC1027	(Peacock blue)	
Reddish purple PC995	(Mulberry)	
Dark green PC988	(Marine gray)	
White PC938	(White)	
Gray PC1072	(French gray 50%)	

Dark gray PC1056	(Warm gray 70%)	
Reddish brown PC1031	(Henna)	
Burnt umber PC947	(Dark umber)	
Beige PC997	(Beige)	
Peach PC939	(Peach)	
Brown PC945	(Sienna brown)	

Artist's Note After coloring the shading with neutral colors, add color with the grisaille technique (page 10) to bring out the coloring of the puppy's intricate coat while maintaining three-dimensionality.

Original Image/Rough Sketch

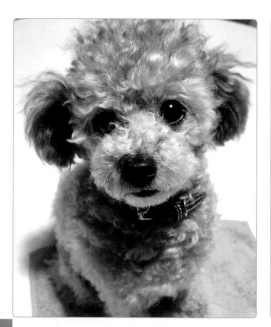

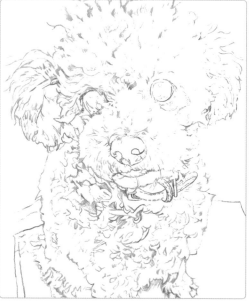

The three key points are
❶ Three-dimensional coloring
❷ Reproduce the distinctive hair of long-haired breeds
❸ Express the differences in focus in the image

For the rough sketch, draw as if you are looking down at the puppy a bit, and take care with the long and slightly curly hair. Draw quite a lot of the hair, so that it can guide you when you do the coloring later.

You should bring out the puppy's distinctive, moist eyes and its unique coat of hair. You can also try to implement various colored-pencil drawing techniques, such as conveying the differences in levels of focus. Have fun seeing what happens when you apply different colors!

Adding Colors

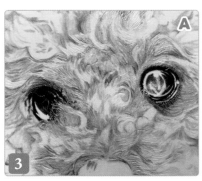

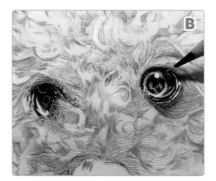

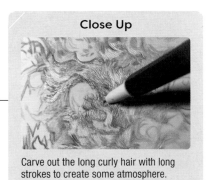

Close Up

Carve out the long curly hair with long strokes to create some atmosphere.

1 Create the direction of hair growth
Color the hair roughly with light gray, as if drawing it. You'll be coloring the eyes and nose first, so focus intensively on those areas.

███ Light gray

2 Carve out the hair
Carve out the hair with a stencil. The trick is to carve the hairs as several clumps, paying attention to the direction of hair growth.

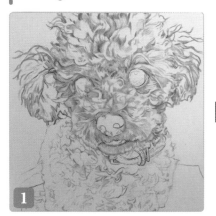

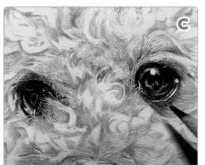

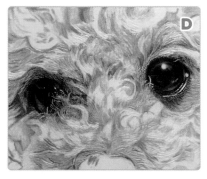

3 Color the eyes
Color the shading and the area around the eyes with black and strong pencil pressure. The trick here is to have carved out the fine highlights beforehand with a stylus (**A**). Then color the nostrils with turquoise (**B**). Then add reddish purple lightly to the whites of the eye in the right of the page and to the reddish area around the eyes (**C**). After applying dark green to the lower half of the eye and its surrounding area, adjust the overall coloring by applying a white finish to the highlights and blurring the surrounding area with dark green (**D**).

███ Black · ███ Turquoise ·
███ Reddish purple · ███ Dark green ·
☐ White

Continues on next page ▶

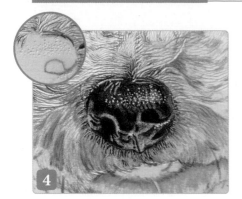

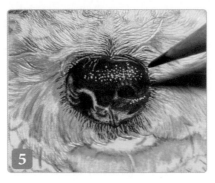

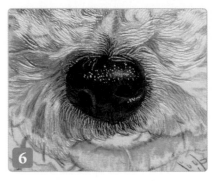

4 **Color the highlights on the nose**
Carve the highlights with a stylus and then color the shading on the nose with black.

■ Black

5 **Apply more color to the nose ①**
Add reddish purple to the nose. Also color the reddish hair around the nose.

■ Reddish purple

6 **Apply more color to the nose ②**
Color over the reflection of the light under the nose with dark green. Also color the greenish hair around the nose.

■ Dark green

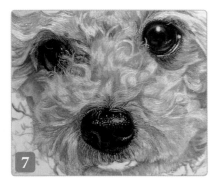

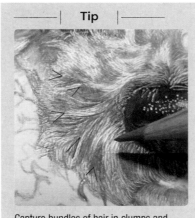

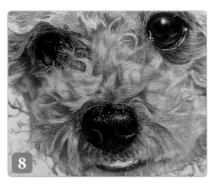

7 **Color the area from the eyes down the muzzle ①**
Color the shading with gray to emphasize the direction of the hair growth.

■ Gray

| Tip |

Capture bundles of hair in clumps and color them so that the shading on their boundaries stands out.

8 **Color the area from the eyes down the muzzle ②**
Color the same area again in the same way as in Step **7** using a dark gray that is a notch darker than the color used in that step. Also color the lips with dark gray. Apply plenty of shading.

■ Dark gray

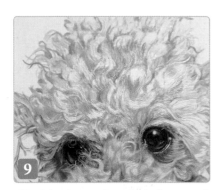

9 **Color the area from the eyebrows to the top of the head**
Carve the hair above the eyebrows with a stylus. The further away you get from the middle of the head in the original image, the more out of focus the hair gets, so the trick is to vary the density of the carving. After that, continue to color in the order of: light gray, gray, dark gray to strengthen the shading.

□ Light gray · ■ Gray · ■ Dark gray

Gradually carve
sparser and sparser

↓ Carve firmly

| Tip |

Express the difference in focus by changing the way you carve from firmly above the eyebrows to more thinly the higher you go.

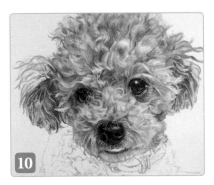

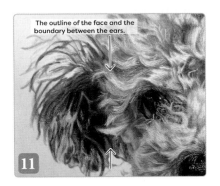

The outline of the face and the boundary between the ears.

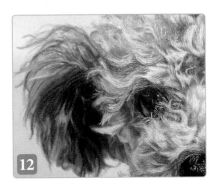

10 Color the ears ①
The ears are darker than the face, so color the shading loosely with dark gray. Color the hairs separately so that the general flow of the hair is visible.

■ **Dark gray**

11 Color the ears ②
Color the shaded areas of the ears with black. Ensure that you make the outline of the face clear.

■ **Black**

12 Color the ears ③
Use three types of gray to color the patterns inside the ears. The trick is to blur the colors because this area is out of focus.

□ **Light gray** · ■ **Gray** · ■ **Dark Gray**

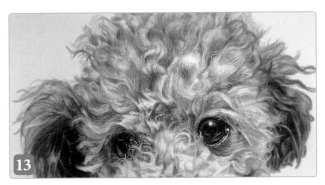

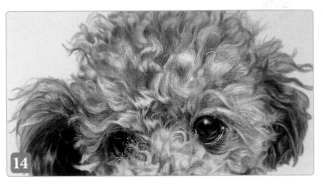

13 Color the whole of the head ①
Color the whole of the head in the same way as the eyes and the area around the nose. First, apply reddish purple to mainly the shaded areas. It's important to keep observing the original image carefully.

■ **Reddish purple**

14 Color the whole of the head ②
The hair on the left side of the page is tinged with green, so apply dark green, mainly to the shaded areas. Also depict the whiskers and areas around the muzzle and eyes with a sharpened pencil.

■ **Dark green**

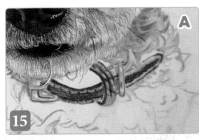

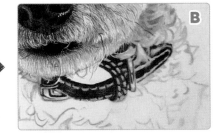

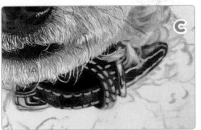

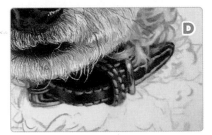

15 Color the collar
Color the stitching and the metal fittings with light gray and the actual collar with reddish brown (**A**). Add shading to the strap and the fittings with burnt umber. The trick is to gradate the color on the strap and to color the fittings crisply (**B**). The slightly bright area on the side of the strap should be colored with beige. Color the darkest part with black to clearly define the outline of the face (**C**). Finally, color the whole of the collar lightly with gray(**D**).

□ **Light gray** · ■ **Reddish brown** ·
■ **Burnt umber** · □ **Beige** ·
■ **Black** · ■ **Dark green**

Continues on next page ▶

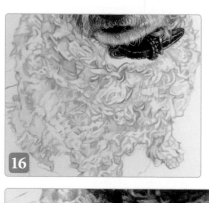
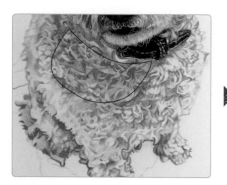
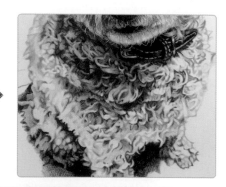

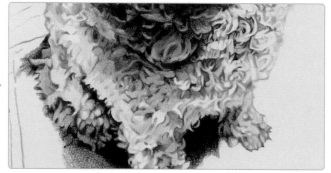
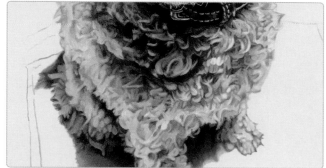

16 Color the body ①

Color the body with light gray, like the head. However, as it is out of focus, just depict the hair with a colored pencil instead of a stylus. Heavily darken the area inside the red rectangle, which is where the face's shadow falls. Also add dark gray to color the shadows around the feet. Color the darkest areas with black. Use three types of gray to blur the finish. However, the trick is to color the blurred areas with a gray that is one shade lighter than the adjoining are and with strong pencil pressure.

Light gray · Gray · Dark gray · Black

Close Up

The above photo shows the blur created by applying a dark gray, which is one shade lighter than the black beside it.

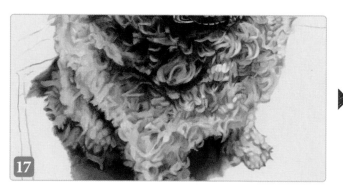
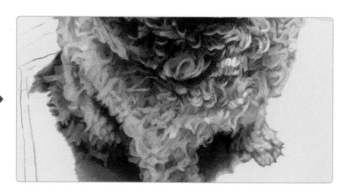

17 Color the body ②

Color with reddish purple, as you did with the head. Take care to ensure that the head and the body have the same coloring. Then add dark green, as there are a lot of areas in the lefthand side of the page that are tinged with green.

Reddish purple · Dark green

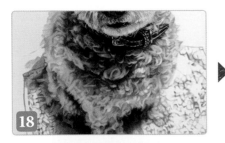
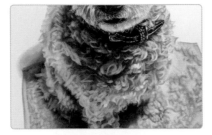
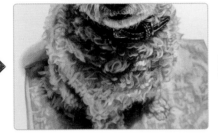
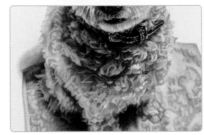

18 Color the floor mat

Color the patterned shading of the carpet in gray. Next, blur the area by coloring it with light gray with strong pencil pressure. Color the surrounding area with a thin layer of gray as well. Color over the patterned area with beige, and adjust the color by coloring over the patterned area with peach and brown. Colver over the drop shadows at the feet with burnt umber.

Gray · Light gray ·
Beige · Peach ·
Brown · Burnt umber

Completion

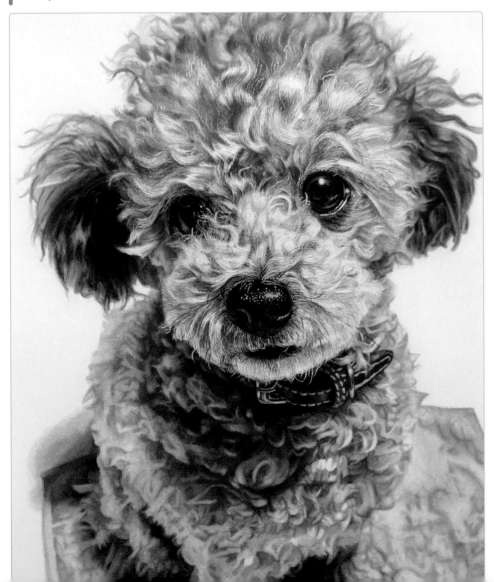

Finally, add dark green to all the drop shadow on the floor to complete.

Cat

 Drawn by Haru Otomi

Drawing Data

- **Rough Sketch:** One hour
- **Adding Colors + Finishing:** Eight hours
- **Sharp Pencil:** Mitsubishi uni Kuru Toga 0.5

- **Colored Pencils:** Charisma Color
- **Colors:** 10
- **Paper:** Daigen Thick White Paper/A4

Color Data

Gray 233	(Cold gray)	
Black 199	(Black)	
Brown 180	(Raw umber)	
Orange 186	(Terra cotta)	
Yellow 184	(Dark Naples ochre)	
Emerald green 153	(Cobalt turquoise))	

White	(White001)*	
Cream 102	(Cream)	
Light gray 271	(Warm gray II)	
Dark Gray 274	(Warm gray V)	

* Caran d'Ache Luminance

Artist's Note The final quality of drawings of cats is determined by their expression of the fine fur and moist eyes, so please take your time to draw this carefully.

Original Image/Rough Sketch

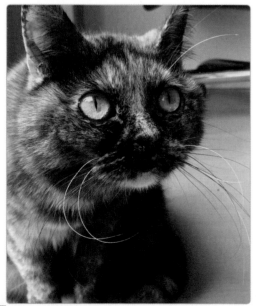

© Yua

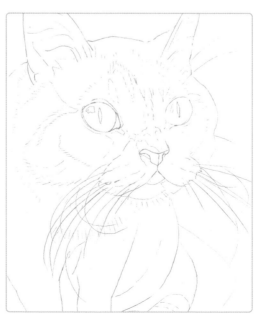

The three key points are
❶ Translucent eyes
❷ Complex coloring with only a few colors
❸ Overall expression of the fur

For the rough sketch, draw the rough shape and create the patterns clearly enough for them to be visible when you are adding the colors later. Use a smartphone app to draw gridlines to help you maintain balance.

For this drawing, you may use tools that you are not very familiar with. Take your time and use different methods.

Adding Colors

 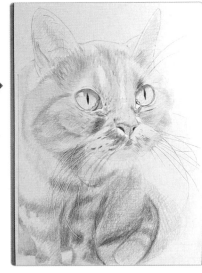

1 **Apply an undercoat for the whole drawing**
Apply the undercoat. In order to have some idea of what colors to use where, color lightly with gray, black, brown, orange, yellow, and emerald green while looking at the original image. As it's an undercoat, the trick is to apply the colors smoothly while holding the colored pencils in a low, almost-horizontal position. Carve out the whiskers beforehand with a stylus.

Gray · Black · Brown · Orange · Yellow · Emerald green

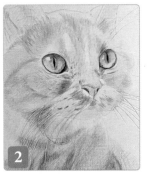 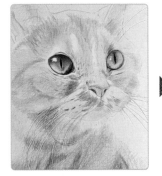 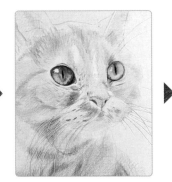 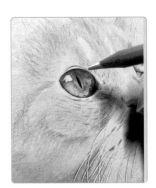

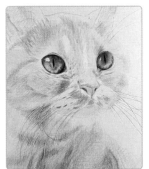 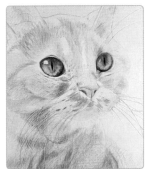

2 **Color the eyes**
Add a small shadow under the top eyelid by applying gray to the edge of the eye. Then strengthen your pencil pressure as you evenly apply gray to the edge of the eye and emerald green to the iris. For the pupil, apply black with strong pencil pressure, and for the highlights apply white to erase the texture of the paper.

Gray · Emerald green · Black · White

Continues on next page ▶

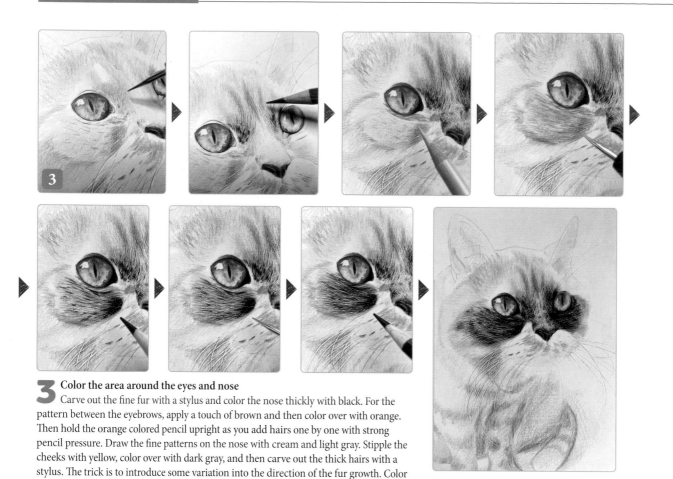

3 Color the area around the eyes and nose

Carve out the fine fur with a stylus and color the nose thickly with black. For the pattern between the eyebrows, apply a touch of brown and then color over with orange. Then hold the orange colored pencil upright as you add hairs one by one with strong pencil pressure. Draw the fine patterns on the nose with cream and light gray. Stipple the cheeks with yellow, color over with dark gray, and then carve out the thick hairs with a stylus. The trick is to introduce some variation into the direction of the fur growth. Color the black fur with black and strong pencil pressure, carve out grooves with a stylus, and then create depth of color by coloring over with black. Color the other side of the face in the same way.

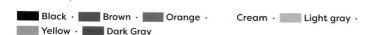

■ Black · ■ Brown · ■ Orange · ■ Cream · ■ Light gray · ■ Yellow · ■ Dark Gray

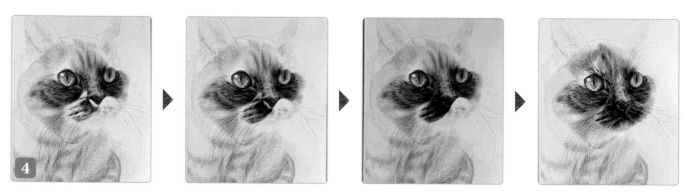

4 Color the muzzle

Color the shadow on the muzzle with black and carve the patterns on it with a stylus. Add subtle highlights and shadows to create fullness and give it three-dimensionality. After coloring the other side of the muzzle in the same way, apply cream lightly to the bottom part of the mouth, darken by coloring over with light gray, and then create depth by coloring over with orange. Then carve out the fur as finely as possible with a stylus and apply gray and black smoothly.

■ Black · ■ Cream · ■ Light gray · ■ Orange · ■ Gray

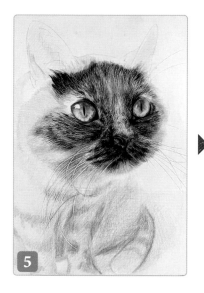

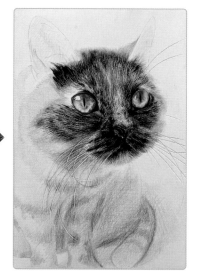

5 Color the forehead and head

Color the black hairs at the edge of the ears thickly in black and then color with gray, brown, and orange, looking closely at the original image. The area from the forehead to the head has a slight perspective effect compared to the surface of the face, so instead of coloring the hairs one by one, use a gradation to create depth by making the hairs darker in the foreground and slightly lighter toward the back of the face. Compared to the face, the area from the forehead back over the head has a slight sense of perspective. You should add depth not by coloring each hair one by one, but by coloring the hair at the front thickly and then gradating the color a bit more lightly the further back you go to create a blur effect.

█ Black · ▨ Gray ·
█ Brown · █ Orange

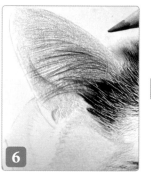
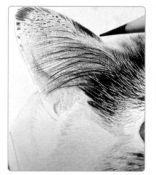
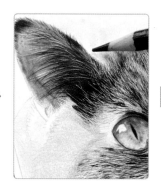
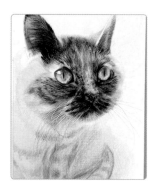

6 Color the ears

Color the black hairs on the ears one by one in detail. Next, for the skin of the ear, increase the color intensity by lightly applying gray and then orange, and then coloring the patterns with orange and cream and strong pencil pressure to represent the shadows and the light shining through the skin. After that, carve grooves with a stylus and lightly apply light gray. Color the other ear in the same way, but be aware that it is slightly out of focus.

█ Black · ▨ Gray · █ Orange · Cream · ▨ Light gray

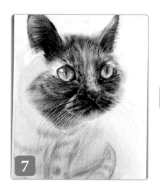
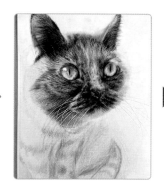
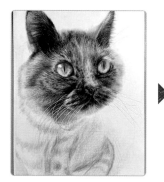
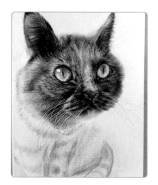

7 Color the bottom of the jaw and the neck

Continue to color in the same way as you did in Step 3 while looking at the original image. Also carve grooves with a stylus in the same way. Add crispness to the orange pattern next to the eyes by thickly applying black after you have applied the orange.

█ Black · █ Brown · █ Orange · Cream · ▨ Light gray · ▨ Yellow · █ Dark gray

Continues on next page ▶

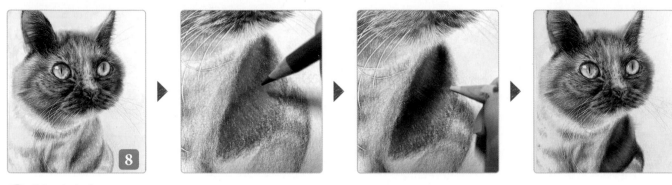

8 Color the body

Color by mixing orange, black, and dark gray while looking at the overall coloring in the original image. Gradually strengthen your pencil pressure to bring out the depth of the color. For the blurred fur, apply light gray at the top to create just the right color that is not too bright.

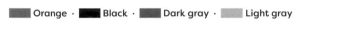

Orange · Black · Dark gray · Light gray

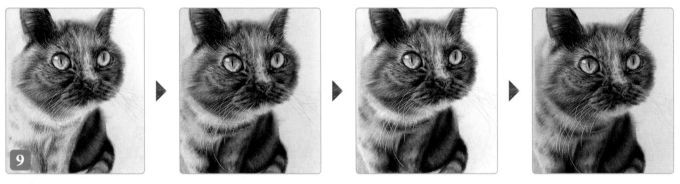

9 Color the tail and forelegs

Color the tail in shades of dark gray and brown to create color gradation. Color the left foreleg in the same way, but take care not to blur either of them so that their outline disappears. Light is shining from the lefthand side of the page, so apply cream to the right side of the right foreleg to make it a bit brighter, and then add light gray to stop it from being too conspicuous.

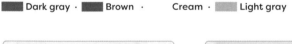

Dark gray · Brown · Cream · Light gray

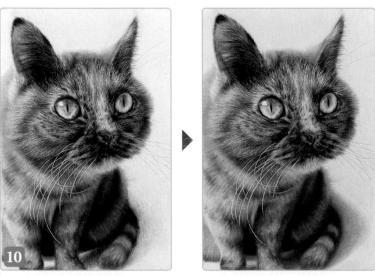

10 Color the drop shadow

To represent the light hitting the cat from the lefthand side of the page, apply cream lightly and then darken with gray. Add a touch of yellow to create a natural shadow.

Cream · Gray · Yellow

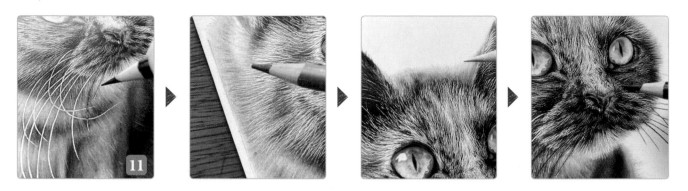

11 Apply the overall finish

Fill the fine whiskers carved in Step **1** with black using strong pencil pressure. Add dark gray and yellow to the soft gray fur. Add a little more fur with dark gray and cream to the blurred area on the top of the head to make it softer and thicker. Finally, add some fine black hairs with the black colored pencil. Create a more natural fur with variations of the rusty color that is so distinctive to cats.

█ Black · █ Dark gray · █ Yellow · █ Cream

| Completion

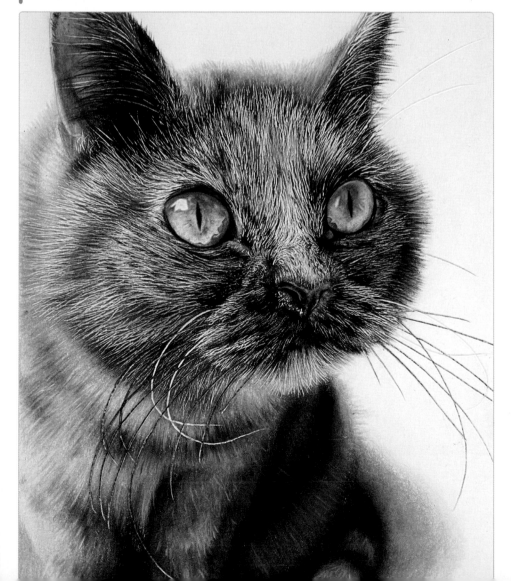

Look at the drawing from a slight distance. If nothing bothers you, it's completed.

Snake

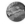 Drawn by Ishikawa @ Colored Penci

Drawing Data

- **Rough Sketch:** Six hours
- **Adding Colors + Finishing:** 50 hours
- **Sharp Pencil:** Mitsubishi Pencil Uni 0.5

- **Colored Pencils:** Charisma Color
- **Colors:** Eight
- **Paper:** White parchment paper/A4

Color Data

Cream PC914	(Cream)	**Light sky blue PC1023**	(Cloud blue)
Green PC911	(Olive green)	**Yellowish green PC1005**	(Lime peel)
Black PC935	(Black)	**Yellow PC916**	(Canary yellow)
Brown PC941	(Light umber)	**White PC938**	(White)

Artist's Note In snakes, the three-dimensionality and highlights of each individual scale contribute to the overall effect. You should color the border between scales after coloring both scales to prevent the lines from becoming too strong. Note that the eyes reflect the color of the body.

Original Image/Rough Sketch

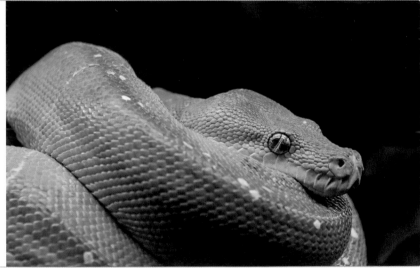

© BreakingTheWalls/PIXTA

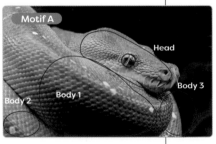

The three key points are
❶ Depiction of the fine scales
❷ Shading that creates three-dimensionality
❸ Depth of the body's colors using just a few colors

 Draw the rough sketch as lightly as possible. You should also draw the scales in as much detail as possible to make it easier to apply the right colors later and to know the correct positions of the boundaries between scales and of shading and highlights.

Snakes are a particularly popular motif among reptiles. This exercise is packed with the basic techniques for drawing reptiles, such as how to draw eyes with intricate patterns and how to draw scales for each part of the body.

Adding Colors

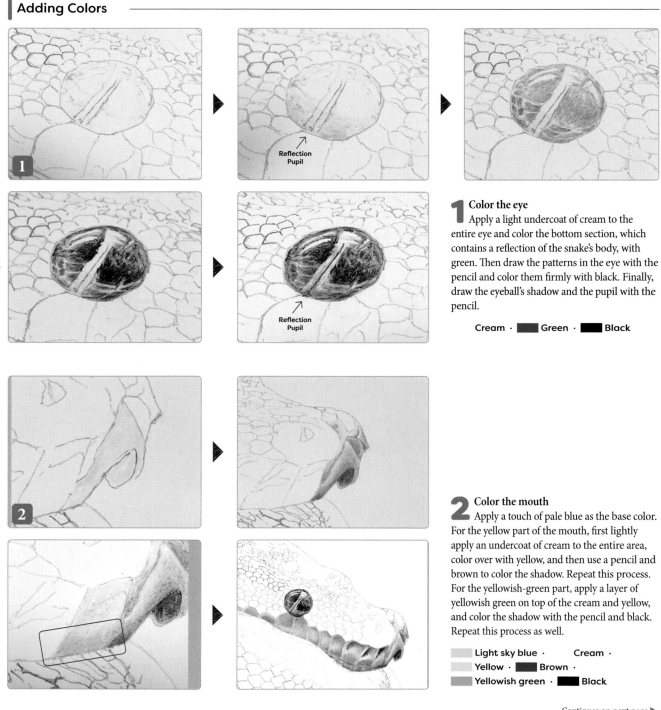

1 Color the eye
Apply a light undercoat of cream to the entire eye and color the bottom section, which contains a reflection of the snake's body, with green. Then draw the patterns in the eye with the pencil and color them firmly with black. Finally, draw the eyeball's shadow and the pupil with the pencil.

Cream · ■ Green · ■ Black

2 Color the mouth
Apply a touch of pale blue as the base color. For the yellow part of the mouth, first lightly apply an undercoat of cream to the entire area, color over with yellow, and then use a pencil and brown to color the shadow. Repeat this process. For the yellowish-green part, apply a layer of yellowish green on top of the cream and yellow, and color the shadow with the pencil and black. Repeat this process as well.

Light sky blue · Cream ·
Yellow · ■ Brown ·
Yellowish green · ■ Black

Continues on next page ▶

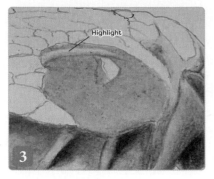

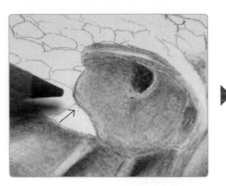

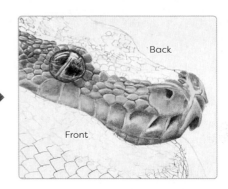

3 Color the nostril

Apply an undercoat of cream to the whole nostril and color over with yellow. Add yellowish green on top, but leave the highlight untouched. Color the nose's cavity and shadow with the pencil and black, but use a strong pencil pressure on the cavity and weak pressure on the shadow on the righthand side of the page. Finally, color the outlines of the scales thickly with brown to create three-dimensionality. Repeat this on the scales in the foreground.

Cream · Yellow · Yellowish green · Black · Brown

Close Up

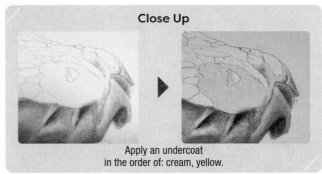

Apply an undercoat
in the order of: cream, yellow.

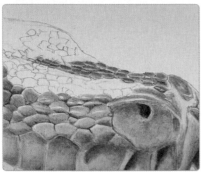

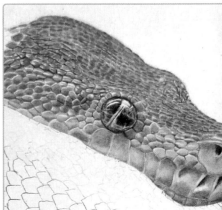

4 Color the back of the head

Apply cream lightly to the whole head as the base color, and then color the shapes of the scales with yellowish green. Color the boundaries of the scales with the pencil to bring out the three-dimensionality. Darken the scales at the back of the head by applying green. Create highlights on the boundaries of the scales by shaving the colored surface with a design knife.

Cream · Yellowish green · Green

Repeat the work in Step 4 when coloring the whole of the back of the head.

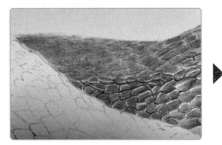
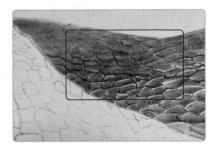

5 Color the out-of-focus areas on the head

The area at the back of the head is not in focus. First, apply a light undercoat of cream, then color over with yellowish green and green to depict the scales. Ensure that you blur the back of the head at this stage. Finally, color the area denoted by the rectangle with black to darken the scale boundaries and add a bit of three-dimensionality.

Cream · ▨ Yellowish green · ▨ Green · ▨ Black

Close Up

Completed head section

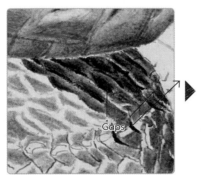
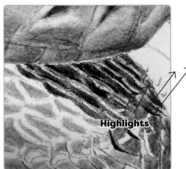

6 Color the body under the mouth

Color the shape of the scales in yellowish green, and color over with green. After creating shadows by coloring the gaps between the scales with black, create highlights by inserting a designer knife in the gaps between the scales and shaving off the colored surface.

▨ Yellowish green · ▨ Green · ▨ Black

Close Up

The area to color in Step **6**.

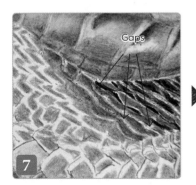

7 Color the upper half of Body 1

Color with yellowish green, leaving slight gaps, and then the color over with green. Repeat this process to color the upper half of Body 1 from (Motif A) on page 80.

▨ Yellowish green · ▨ Green

Close Up

The area to color in Step **7**.

Continues on next page ▶

Close Up

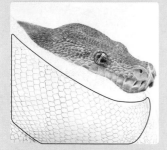

The area to be colored in Steps **8** - **9**. As the bottom half of Body 1 that needs to be colored is a large area and the scales are also intricate, Steps **8** and **9**, will explain what you have to do in fine detail. Repeat this process to color the bottom half of Body 1.

8 The green scales in the bottom half of Body 1
Color over with yellowish green and green, remembering to leave highlights.

■ Yellowish green · ■ Green

9 The yellow scales in the bottom half of Body 1
Apply a cream base coat and then color over with yellow, remembering to leave highlights.

Cream · ■ Yellow

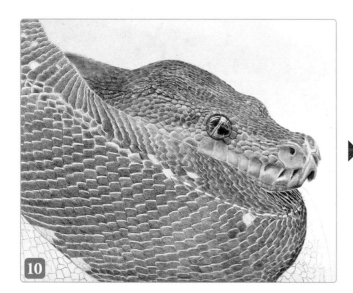

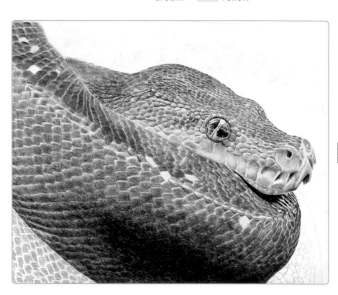

Close Up

Color the shadow between Body 1 and Body 2 with the pencil and black, using a strong pencil pressure.

10 Finish the bottom half of Body 1 and color Body 2
After repeating Steps **8** and **9**, use yellowish green and yellow to color the highlighted areas of the scales, and roughly color the shadows around the lower part of the middle of the page using the pencil and black. Color Body 2 from **Motif A** on page 80 in the same way as Steps **8** and **10**.

■ Yellowish green · ■ Yellow · ■ Black · ■ Green

84

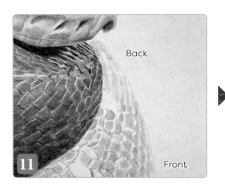
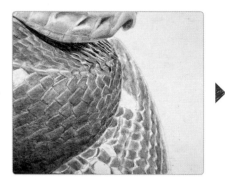
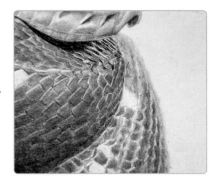

11 Color Body 3

Color the back of Body 3 in ⬭Motif A⬭ on with white as the base color, and then color over with yellowish green and green to represent the scales. Color the front clearly, but blur the back. After that, apply shadows with the pencil and black. Color the yellow areas with yellow. Color shadows between the scales with the pencil and black to create three-dimensionality.

☐ White · ▨ Yellowish green · ▰ Green · ▰ Black · ▨ Yellow

—| **Tip** |—

As a final adjustment, color shadows on the scales on Body 1. The photo on the left shows how the shadows should be colored.

| Completion

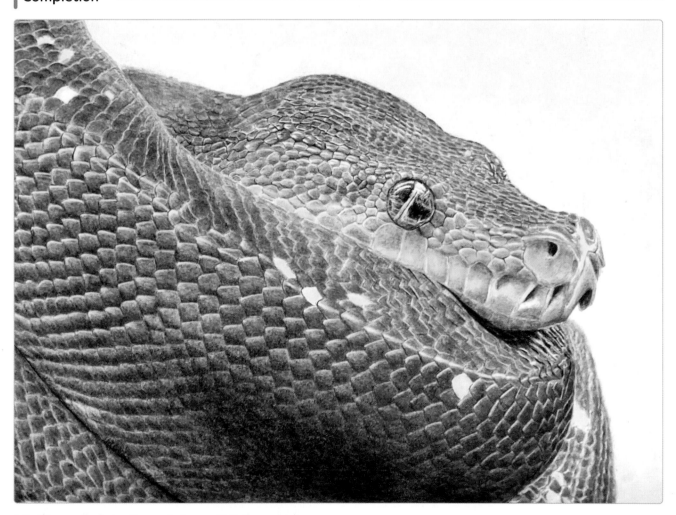

Adjust the overall coloring. Once you're happy with it, it's completed.

Clouds

 Drawn by Licht

Drawing Data

- **Rough Sketch:** Two hours
- **Adding Colors + Finishing:** 28 hours
- **Pencil:** Any

- **Colored Pencils:** Faber-Castell Polychromos
- **Colors:** Six
- **Paper:** KMK Kent Paper/A4

Color Data

Sky blue 140	(Light ultramarine)	
Dark sky blue 120	(Ultramarine)	
Blue 110	(Phthalo blue)	

Dark blue 247	(Indanthrene blue)	
White 101	(White)	
Light gray 231	(Cold gray II)	

Artist's Note For this drawing, we will use mainly sky blue and blue for the sky and the shading of the clouds. The dark blue is used a lot for the area in the top righthand corner of the page where the sky is at its darkest. Use the light gray for shading of the dull clouds and the white for burnishing (page 10). When coloring the clouds, please remember to hold the pencil low in an almost-horizontal position and to apply the colors with a gentle touch.

Original Image/Rough Sketch

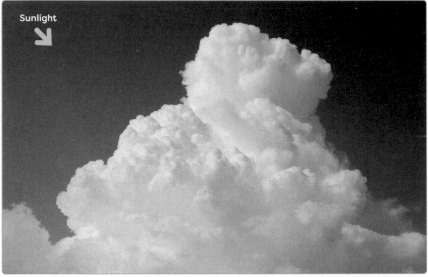
© PIXTA

The three key points are
1. Direction of the sunlight
2. Billowing of the clouds
3. Expression of light and shade

The sunlight shines in the direction of the arrow, from top left to bottom right. The billowing looks like spheres stuck to each other. Strongly depict the contrast in light and shade inside the yellow rectangles in **Motif A**. For the red rectangles, color smoothly and gently without accentuating the differences in light and shade too much.

A landscape drawing looks more stylish if you can include billowing clouds and a blue sky. Let's use lots of basic techniques, such as the expression of light and shade, color layering, and burnishing.

Adding Colors

1 Apply the base color for the sky
Hold the pencil in a low, almost-horizontal position as you smoothly apply sky blue as the base color for the sky, while carefully observing the original image.

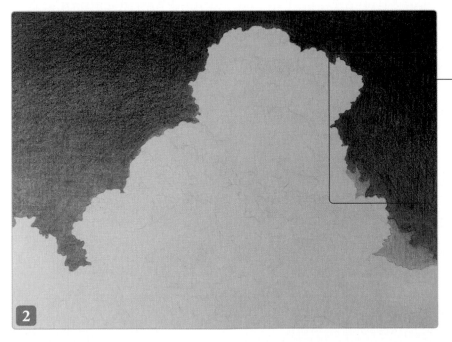

Close Up

■ Sky blue
Use a lot of dark blue and blue in the top righthand corner of the page.

2 Layer more colors on the sky
Color over the entire sky with layers of sky blue and dark blue, adding blue mainly to the top left and right side of the page. Apply even more dark blue around the top righthand corner of the page where the sky is at its darkest. Overall, try to make the sky darker towards the top righthand corner.

■ Sky blue · ■ Dark sky blue ·
■ Blue · ■ Dark blue

Continues on next page ▶

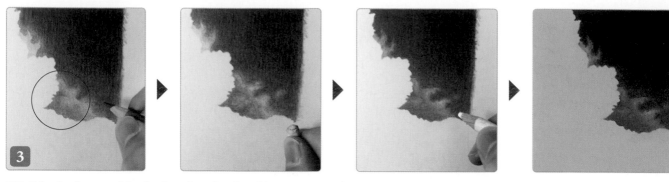

3 Color the sky around the clouds in the right edge of the page

Color the area inside the red circle ⃝ with sky blue and dark sky blue. Color so that the area around the boundary with the sky turns white. After that, add more blue and then rub gently with a kneaded eraser to give the clouds a natural shape. Adjust the shapes of the clouds by coloring them in the order of: sky blue, dark sky blue, blue. Finally, burnish (❯ page 10) them with white.

■ **Sky blue** · ■ **Dark sky blue** · ■ **Blue** · ☐ **White**

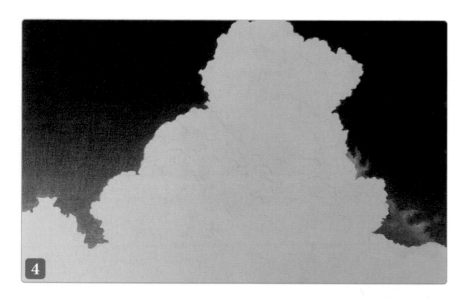

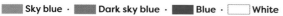

Tip

Use a lot of dark blue and blue around the top righthand corner of the page.

4 Color the entire sky

Color the entire sky in the order of: sky blue, blue, dark blue with a strong pencil pressure. Ensure that the area around the top righthand corner of the page turns dark.

■ **Sky blue** · ■ **Blue** · ■ **Dark blue**

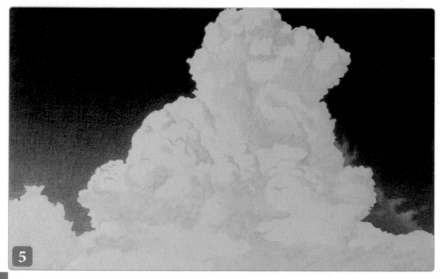

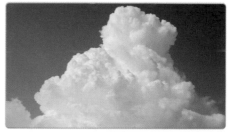

Original image

5 Color the shaded parts of the clouds ①

Smoothly color the shaded parts of the clouds with light gray, holding the pencil in a low, almost- horizontal position. At this stage you are determining the rough shapes of the clouds.

■ **Light gray**

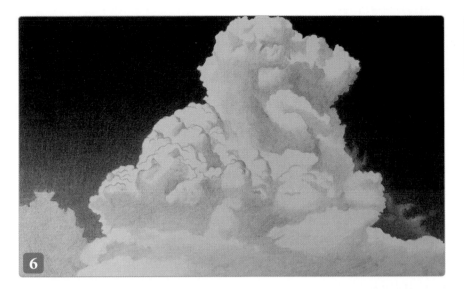

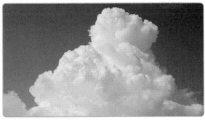

Original image

6 Color the shaded parts of the clouds ②

Apply a layer of sky blue to the shaded areas of the clouds while looking carefully at the original image. This will create three-dimensionalities.

■ **Sky blue**

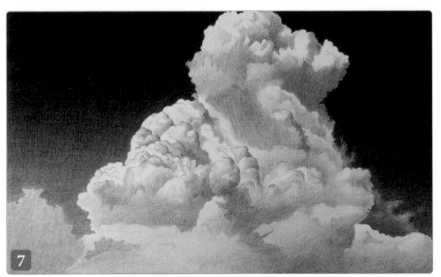

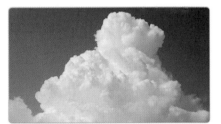

Original image

7 Color the shaded parts of the clouds ③

Apply more sky blue to the shaded parts of the clouds while looking carefully at the original image. This will enhance the three-dimensionality.

■ **Sky blue**

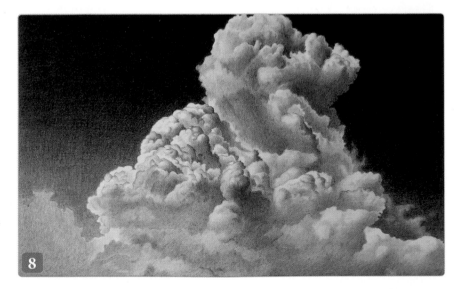

Original image

8 Color the shaded parts of the clouds ④

Add blue to the darkest shaded parts of the clouds to define the shapes of the clouds.

■ **Blue**

Continues on next page ▶

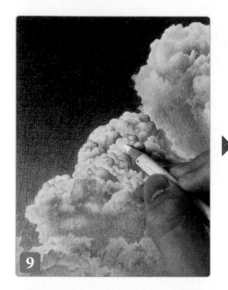

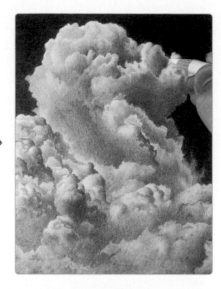

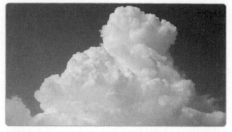

Original image

9 **Color the bright areas in the sky**
Color the bright parts of the clouds with white, while looking carefully at the original image.

☐ White

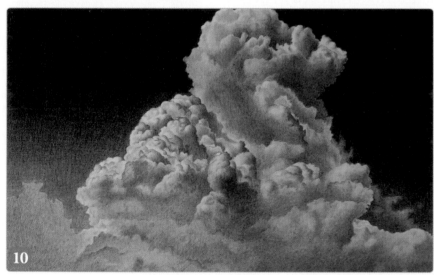

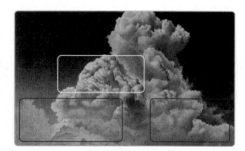

10 **Distinguish between light and shading**
Color the shaded areas on the clouds inside the areas inside the red rectangles with light gray to make them look smoother. This will accentuate the differences between light and shading and emphasize the clouds inside the red rectangles.

▨ Light gray

11 **Make slight adjustments to the finish**
Color the fine shadows and shades. Define the bright clouds in the shadows by shaving the colored surface with a designer knife. The trick is to shave the surface while holding the designer knife as parallel as possible to the paper without applying too much pressure.

■ Blue

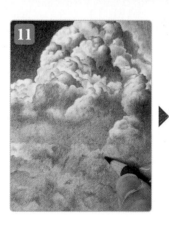

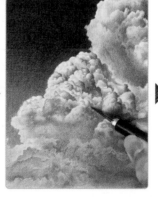

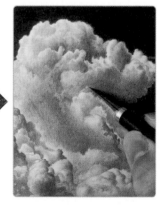

Completion

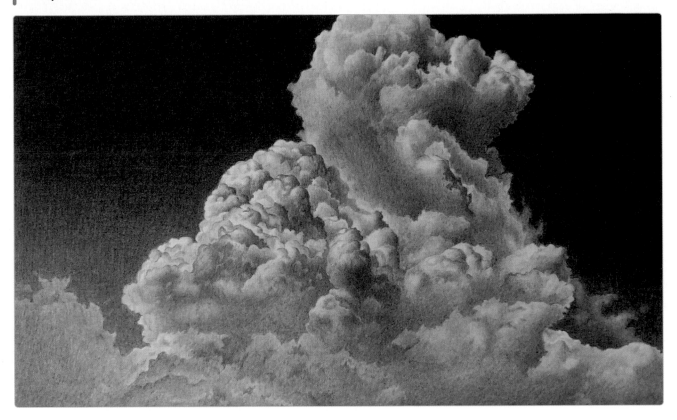

Look at the drawing from a slight distance. If nothing bothers you, it's completed.

Tree

 Drawn by Ryosuke Mika

Drawing Data

- **Rough Sketch:** Two hours
- **Adding Colors + Finishing:** 15 hours
- **Sharp Pencil:** Mitsubishi Hi-uni B

- **Colored Pencils:** Charisma Color
- **Colors:** Five
- **Paper:** KMK Kent Paper/B4 Large

Color Data

Blue PC1022	(Mediterranean blue)	
Yellow PC916	(Canary yellow)	
Reddish purple PC930	(Magenta)	

Black PC935	(Black)	
White PC938	(White)	

Artist's Note If you look carefully at an actual tree, you'll see that it's not just green, but also has yellow in bright areas and blue and reddish colors in dark areas. Create the green color by combining red and yellow, and then turn it into natural green with depth by adding reddish purple and black.

Original Image/Rough Sketch

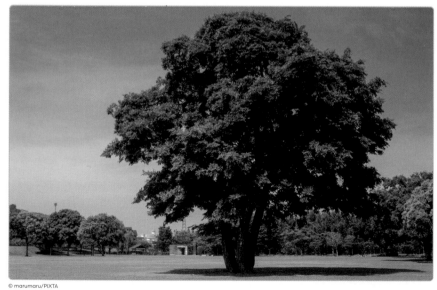

© marumaru/PIXTA

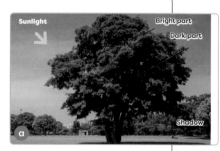

The three key points are
❶ Lightness and darkness throughout the entire tree
❷ Irregular arrangement of the leaves
❸ Color mixing that creates a natural green
 For the rough sketch, try not to draw the outlines of the leaves too regularly or clearly, as their size and direction are characterized by variety and irregularity. Don't draw the background sky or trees. The three main techniques to be used on the tree are
❶ Zigzag lines,
❷ Cross-hatching
❸ Stippling

This is the perfect motif for someone who wants to try their hand at landscape pictures in the future. It may look a bit difficult, but the basic parts, such as understanding light and shade, are not that different to other motifs.

Adding Colors

1 Apply the base color
Instead of using a green colored pencil, you can create a more natural green with depth by combining various colors. The shading during the day often looks a bit bluish, so first color the leaves with blue. There is no need to depict each individual leaf. It's fine to make it look as if there are lots of leaves. You can use the techniques listed in ❶ to ❸ on page 92 separately or together.

▮ Blue

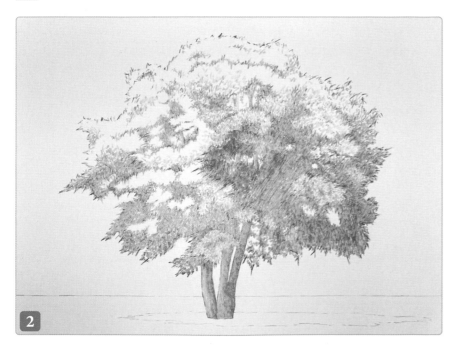

| Tip |

Bright area

Dark area

Apply shading that shows the effect of the source of light coming from the top lefthand corner of the page.

2 Be aware of the overall shading
When coloring leaves, people always tend to focus only on their details, but it's also important to be aware of the overall shading. You should therefore color the dark areas thickly and the bright areas a bit lightly.

▮ Blue

Continues on next page ▶

Tip

The shape of the tree is easier to understand if you replace it with the simple shape shown above.

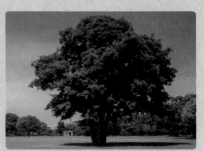

The tree itself has depth, so, if you can differentiate the leaves at the front from the leaves at the back, you can create depth and a three-dimensional effect (right photo). Also pay attention to the part of the tree that has few leaves, allowing you to the see through to the other side (left photo).

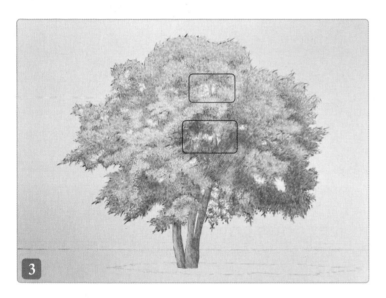

3

Tip

If you have overcolored any areas, you can rub them out with an electric eraser.

3 Color the areas visible between the leaves

Don't forget to color the branches and twigs that are visible between the leaves with blue.

▆ Blue

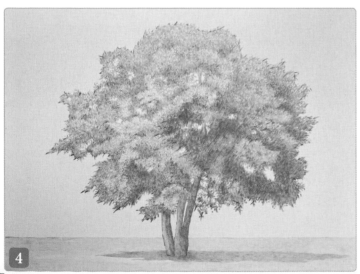

4

Tip

Point Color the drop shadow from the tree quite lightly.

4 Color the ground

Color the ground smoothly and lightly with blue. Don't forget to color the drop shadow as well.

▆ Blue

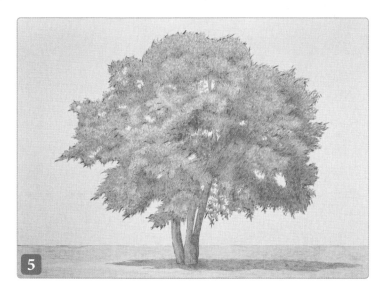

5 **Color over the leaves**
Color over the leaves in the same way as in Step **1**, but this time using yellow. Apply it thickly with quite strong pencil pressure to the bright areas, while always remaining aware of the overall brightness and darkness, and focus on bright areas. Use any of the techniques listed in ❶ - ❸ on page 92.

▢ **Yellow**

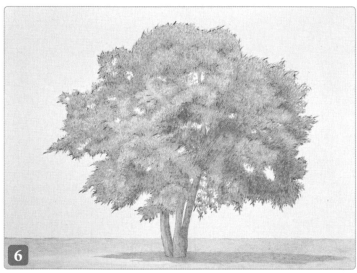

6 **Color over the ground**
Color over the ground in the same way as in Step **4**, but this time using yellow lightly. Also color the drop shadow slightly. Mixing yellow with the base color of blue creates green.

▢ **Yellow**

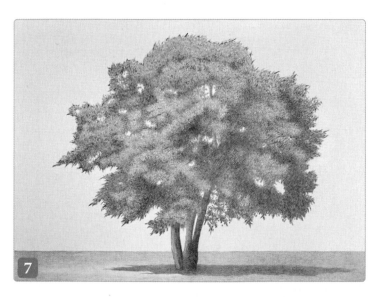

7 **Add depth the color of the leaves** ①
To add depth to the green, apply reddish purple to the dark areas. Take care not to add too much color, as that would turn them into maple leaves. Use any of the techniques listed in ❶ - ❸ on page 92. Also color the ground and the drop shadow lightly.

■ **Reddish purple**

Continues on next page ▶

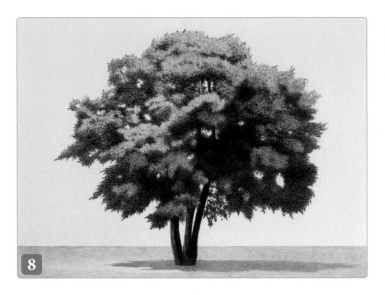

8 Add depth the color of the leaves ②

To add more depth, add black mainly to the dark areas. Sometimes adding black can make something look dirty, but as you are adding it on top of blue, yellow, and reddish purple it turns into a black with depth. Use technique ❸ from page 92 often. Also apply black with a strong pencil pressure to the drop shadow.

■ **Black**

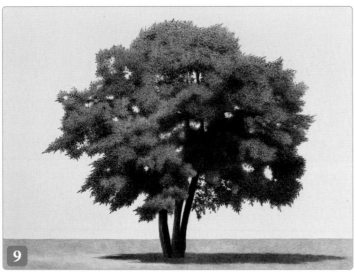

9 Finish the details

Finish by adding any colors that you think are insufficient. In this example, I added yellow to the bright areas on the leaves, blue to the ground, and a bit of reddish purple to the trunks.

▢ Yellow · ▩ Blue · ■ Reddish purple

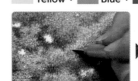

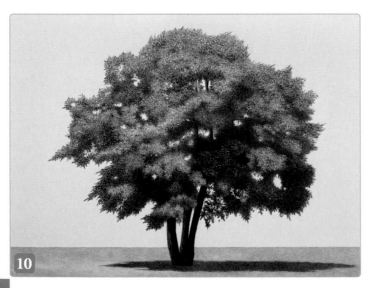

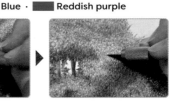

10 Make the bright areas brighter

Make the bright areas even brighter by shaving their surface with a designer knife. Shave until you can see the yellow that was applied in Step ⑤ The trick is to hold the designer knife low, almost horizontal to the paper, to represent the leaves. Take care not to apply too much pressure.

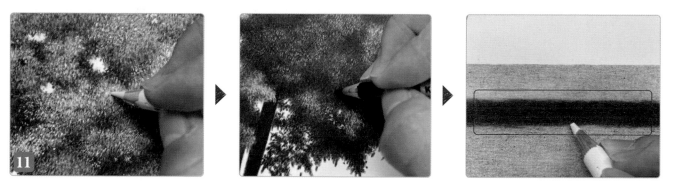

11 Make subtle adjustments to the whole drawing

Once again, add yellow and black to define the shading. Blur the outline of the drop shadow to create natural shading. If you think any colors are lacking at this stage, you can add them now.

▢ Yellow · ▇ Black · ▢ White

| Completion

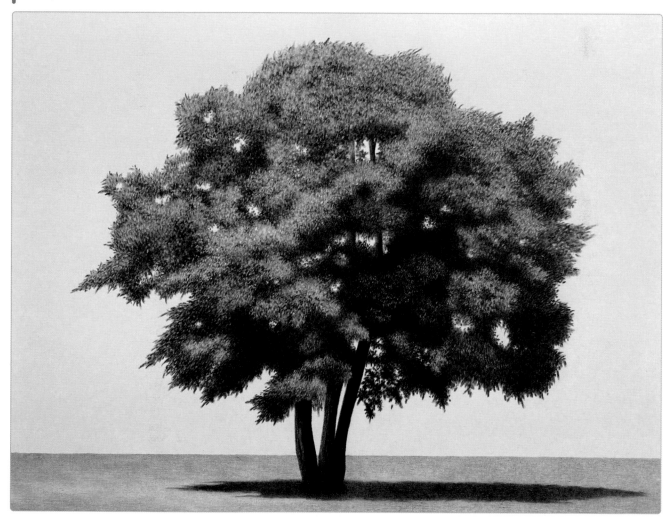

Look at the whole drawing from a slight distance. If there's nothing that bothers you, it's completed.

Mailbox

 Drawn by Ryosuke Mika

Drawing Data

- **Rough Sketch:** Three hours
- **Adding Colors + Finishing:** 10 hours
- **Sharp Pencil:** Mitsubishi Pencil Uni 0.5

- **Colored Pencils:** Charisma Color
- **Colors:** 10
- **Paper:** KMK Kent Paper/B4 Large

Color Data

Deep brown PC948	(Sepia)	
Yellow PC916	(Canary yellow)	
Red PC922	(Poppy red)	
Pink PC929	(Pink)	
Dark red PC925	(Crimson red)	

Dark blue PC901	(Indigo blue)	
Sand PC940	(Sand)	
Dark orange PC1032	(Pumpkin orange)	
Black PC935	(Black)	
Matcha PC988	(Soft yellowish-green)	

Artist's Note After adding the shading with deep brown, create depth of color by coloring first with yellow and then coloring over with red, pink, and dark red. Then use dark blue to add more depth. There are two key ways of coloring required: ①Hold the colored pencil a bit flat, leaving barely any space between it and the paper, and ② Draw lines while holding the colored pencil upright (hatching or cross-hatching).

Original Image/Rough Sketch

© PIXSTAR/PIXTA

- **Bright area:** The area exposed to the light (left of the page)
- **Middle area:** Medium brightness between the bright area and the dark area (middle of the page)
- **Dark area:** The area not exposed to the light
- **Shadow:** The dark area that is created by blocking the light

The three key points are
❶ Be aware of the light source
❷ Depict the bright, dark, and central areas differently
❸ Avoid monochromatic coloring

 For the rough sketch, draw the external shape properly. However, as the photo was taken at a slight angle looking down, be aware that the mailbox gets thinner the lower down you get and the ellipse seems to bulge out the higher you go.

A mailbox has a simple shape, so is probably easier to draw than the other landscape works. Take care to capture the subtle changes in shading. Once you can draw a mailbox, you should also be able to take on proper landscape drawings.

Adding Colors

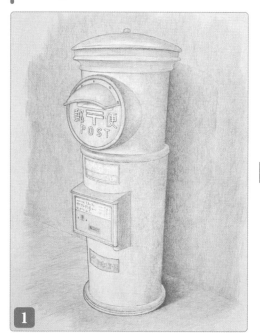

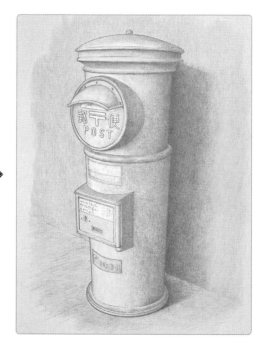

1 Apply shading to the entire mailbox

Apply shading using deep brown while looking carefully at the original image. Hold the colored pencil a bit flat, and don't leave any gaps while coloring. Don't forget that the light is coming from the left side of the page. Be aware of not just the bright and dark areas, but also the central area. Create more three-dimensionality by enhancing the differences between the light and dark areas.

▬ Deep brown

Close Up

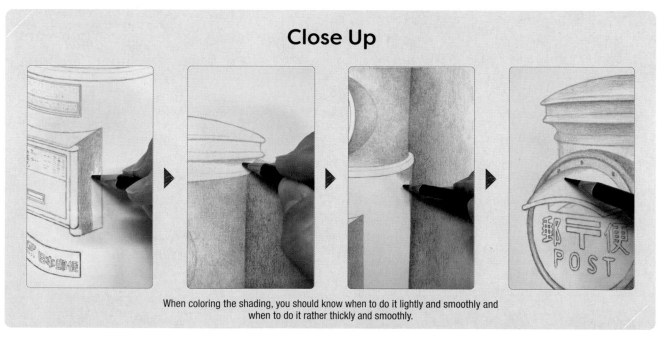

When coloring the shading, you should know when to do it lightly and smoothly and when to do it rather thickly and smoothly.

Continues on next page ▶

2 Color with yellow

Color the whole mailbox with yellow. If you just color with orange, the drawing will become monochromatic. You should therefore mix red and yellow. Also add a bit of yellow to the ground and the wall behind.

Yellow

Tip

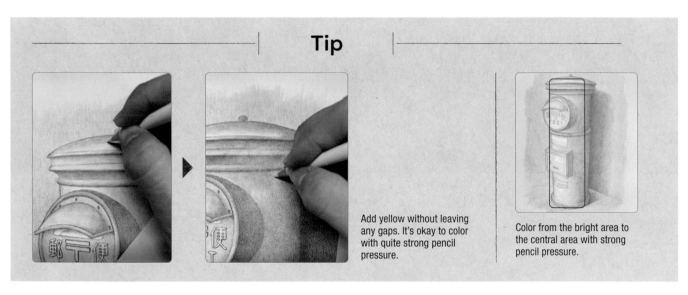

Add yellow without leaving any gaps. It's okay to color with quite strong pencil pressure.

Color from the bright area to the central area with strong pencil pressure.

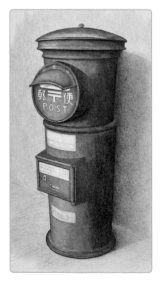

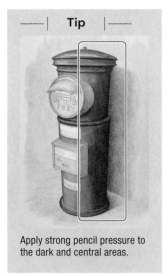

Tip

Apply strong pencil pressure to the dark and central areas.

3 Color over with red

After you've finished coloring with yellow, color over with red, leaving as few gaps as possible. Also add red smoothly to the mailbox's shadow.

Red

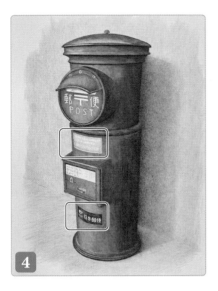

4

Close Up

Don't color the areas where the text is, but leave them blank on the white paper.

4 Color the areas where the text is

Color the area where the small text is in the top rectangle ☐ with pink, and the area where the larger text is in the bottom rectangle ☐ with dark red.

■ Pink · ■ Dark red

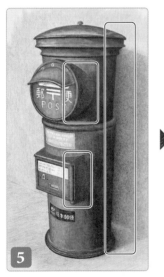

5

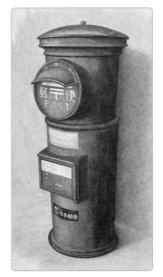

5 Color the dark areas more thickly

Color the dark areas even more thickly with dark blue. Using blue, which is the complementary color of orange, creates depth of color. At this stage, just coloring while leaving as few gaps as possible would make the overall drawing too soft, so you should convey the hardness of the mailbox by coloring with lines (hatching or cross-hatching). The trick to hatching is to draw vertical, horizontal, and diagonal lines leaving just a small space between them. Draw them a bit more lightly on areas exposed to reflected light. If you overdraw the lines, lighten them with an eraser.

■ Dark blue

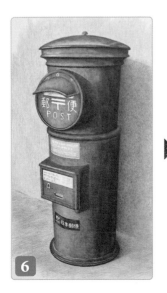

6

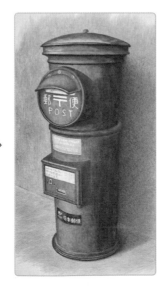

6 Color the floor and wall

Color the floor with sand and dark orange, and the wall with dark orange and deep brown. For both, color lightly and smoothly. Blur the shadow cast by the mailbox with something like tissue paper to stop the shadow's outline becoming too well defined. The photo with the blue cross ✕ is an example of bad shading because the outline is too well defined.

■ Sand · ■ Dark orange · ■ Deep brown

Continues on next page ▶

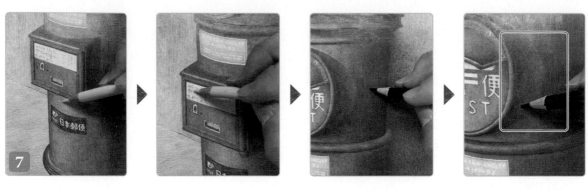

7 Add finish to the detailed areas ①

Add yellow to the areas that lack brightness, adding a bit of yellow to the detailed areas. As there is a lack of redness in the dark and central areas, add dark red. The trick is to incorporate a little bit of line-based coloring. Also add red to the area denoted by the rectangle ☐ to the right of the slot.

☐ **Yellow** · ■■ **Dark red**

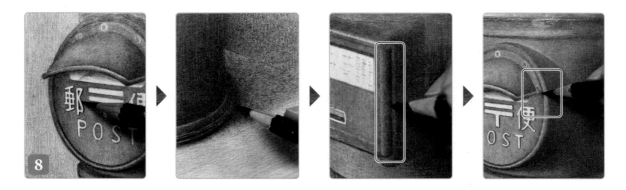

8 Add finish to the detailed areas ②

Drawing the shadow around the text in black also brings three-dimensionality to the text. Also add black to the section of the mailbox that touches the ground to make it stand out. Enhance three-dimensionality by also adding black to the area denoted by the red rectangle ☐. There's no need to draw the text clearly.

■■ **Black**

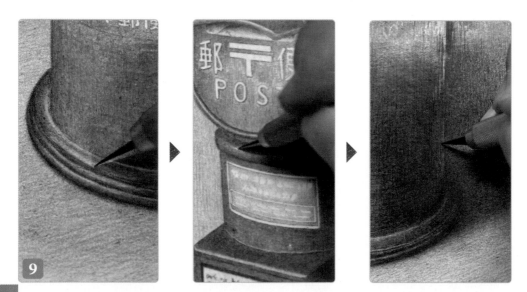

9 Insert highlights

Insert highlights by shaving the colored surface with a designer knife. Take care not to apply too much pressure. Also slightly shave the area exposed to reflected light (the third photo) with a designer knife.

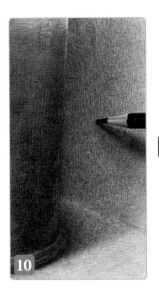
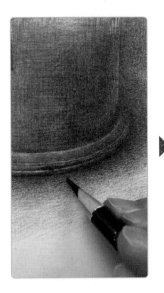
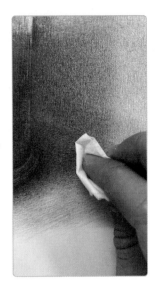

10 Slight adjustments to the overall drawing

Check that there's nothing wrong with the colors and the balance of light and darkness. In this exercise, I created depth by adding dark blue to the shadows and brown to the wall. You should also add deep brown to the section of the mailbox that touches the ground. If the outline of the shadow is too clear, blur it with tissue paper or something similar.

■ **Dark blue** · ■ **Brown** ·
■ **Deep brown**

Completion

Compare it with the original image. If there's nothing that bothers you, it's complete.

Wooden Walls

 Drawn by Licht

Drawing Data

- Photo Shoot + Rough Sketch: Three hours
- Adding Colors + Finishing: 47 hours
- Pencil: Any

- Colored Pencils: Faber-Castell Polychromos
- Colors: 20
- Paper: KMK Kent Paper/A4

Color Data

Light reddish gray 271	(Light gray)	Light gray 231	(Cold gray II)	Brown 283	(Burnt sienna)		
Sky blue 140	(Gray)	Gray 233	(Cold gray IV)	Red 126	(Permanent carmine)		
Yellow 107	(White)	White 101	(White)	Burnt umber 176	(Van Dyke brown)		
Orange 115	(Dark gray)	Dark gray 274	(Warm gray V)	Reddish brown 187	(Burnt ochre)		
Skin 132	(Black)	Black 199	(Black)	Cream 102	(Cream)		
Dark blue 247	(Dark sky blue)	Dark sky blue 120	(Ultramarine)	Pale yellow 103	(Ivory)		
Dark red 142	(Earthen yellow)	Earthen yellow 180					

Artist's Note For this exercise, you will use mainly dark red and dark blue for the shading. In some places, you'll create shading with depth by coloring over with orange, red, and other colors. Use the grays for foundations and stones and the browns for wooden planks, wooden posts, and stains. Create warmth by using the skin colors for the places exposed to sunlight. Use white for burnishing (page 10).

Original Image/Rough Sketch

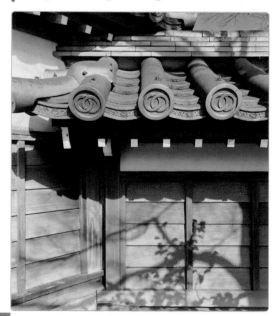

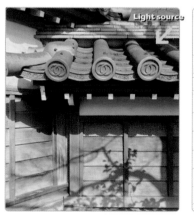

The three key points are
1. The sunlight shines from the top right to the bottom left
2. Complex shapes
3. Expression of shading

For the rough sketch, draw the whole sketch with a light pencil pressure while looking carefully at the original image. If you think you're going to struggle to color the shadows, you should lightly draw them in beforehand so that you know where they are.

This is the last motif of this book. It is a mixture of tiles, wooden planks, stones, and blue sky. Try to capture all the different textures in your drawing. You can make your drawing more realistic by carefully observing the light and the dark and thinking about what is going on where. Now is the time to make full use of the techniques, knowledge, and sensations that you have acquired so far in this book.

Adding Colors

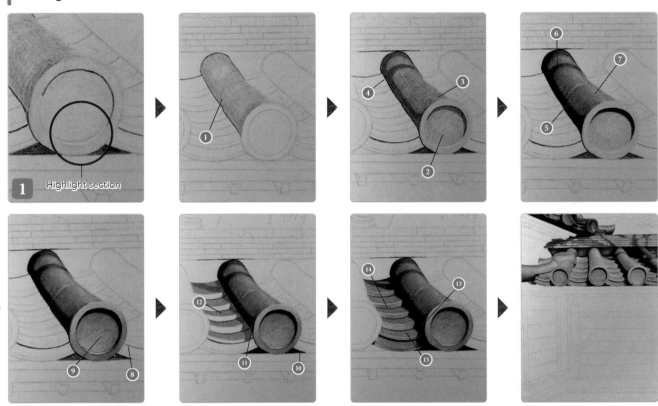

1 Color the tile

Color the tiles lightly with the light reddish gray, but leave the highlight areas untouched.

Apply sky blue, yellow, and orange in that order as the base colors to ①, and burnish with skin (⊙ page 10).
Color ② with sky blue, and ③ with dark blue followed by dark red. After coloring ④ with dark red, burnish the whole tile with light gray.
Color ⑤ with orange, sky blue, and gray in that order.
Add luster to the tile by coloring ⑥ with dark blue and ⑦ with white.
Make the highlights stand out by darkening ⑧ with gray and dark gray. After coloring ⑨ with sky blue, yellow, and gray, burnish with white.
Color out with dark blue and black. Color ⑪ with dark blue, and ⑫ with sky blue, light reddish gray, orange, yellow, and gray in that order.
Darken ⑬ with dark blue, dark red, and black. Color ⑭ with sky blue, light gray, and gray.
Color ⑮ with dark sky blue, dark blue, and dark red in that order.
Finally, burnish the whole tile with white.

■ Light reddish gray · ■ Sky blue · □ Yellow · ■ Orange · □ Skin · ■ Dark blue · ■ Dark red ·
■ Light gray · ■ Gray · □ White · ■ Dark gray · ■ Black · ■ Dark sky blue

2 Color the wooden planks

Apply light gray and earthen yellow to all the planks in that order. After that, color all of them with brown while being aware of the woody patterns on

Continues on next page ▶

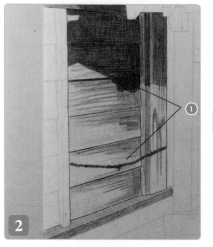

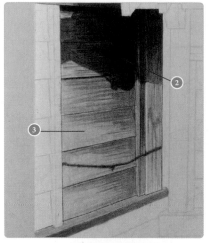

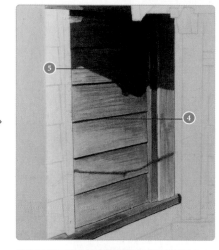

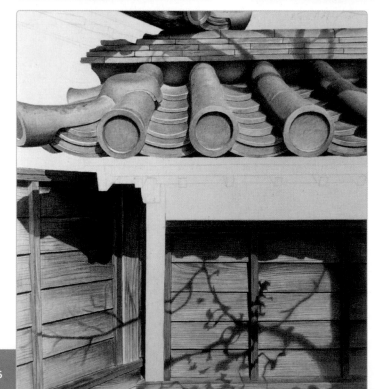

them, and color ❶ with dark blue and red in that order.

Color ❷ with black, dark blue, orange, and red in that order, and then color ❸ lightly with earthen yellow.

After burnishing all the planks with skin (▶ page 10), depict ❹ with dark blue and dark red in that order and then color ❺ with burnt umber.

Color ❻ with dark blue and dark red in that order. Depict the fine lines with a sharp pencil.

Burnish ❼ with white and color ❽ with burnt umber. Depict the grain of the wood with burnt umber and the grain in the shadows with a sharp pencil.

Light gray ·	Earthen yellow ·	Brown ·	
Dark blue ·	Red ·	Black ·	Orange ·
Skin ·	Dark red ·	Burnt umber ·	White

3 Color the plaster and wooden posts

Apply the undercoat for ❶ with light reddish gray and reddish gray in that order and for ❷ with cream smoothly and with weak pencil pressure, adding color gradation with yellow on top. Leave the

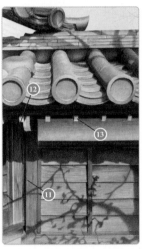
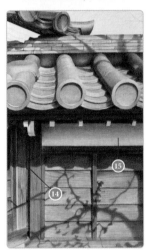

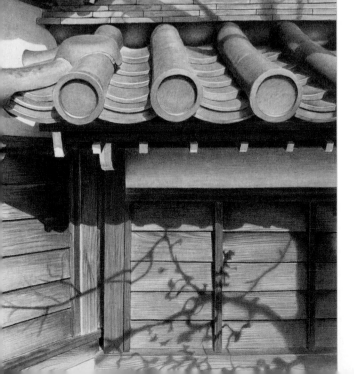

white rafters untouched.

Color ③ with red, and color over ④ with dark blue, dark red, and orange in that order. Color over ⑤ with earthen yellow, sky blue, cream, and pale yellow in that order. At this stage, apply color gradation by making it darker towards the top.

Color ⑥ with brown, and darken ⑦ with black, dark blue, and dark red. Add color gradation to ⑧ with orange and yellow in that order so that it gets darker towards the top. Finally, burnish with skin.

Darken ⑨ by coloring over with dark red, orange, burnt umber, and black. Darken the shadow on ⑩ with dark sky blue.
Color over ⑪ with orange, dark blue, and dark red in that order. Use sky blue, cream, and white to bring out the three-dimensionality of ⑫. Color over ⑬ with cream, yellow, and gray in that order.

Draw the grain on ⑭ with burnt umber. You should sharpen your pencil well. Color over ⑮ with yellow, orange, and add color gradation towards the top by using a lot of dark red and burnt umber. Finally, burnish with pale yellow.

Light reddish gray · Reddish brown ·
Cream · Yellow · Red · Dark blue ·
Dark red · Orange · Earthen yellow ·
Sky blue · Pale yellow · Brown ·
Black · Skin · Burnt umber ·
Dark sky blue · White · Gray

4 Color the foundations and stones
Color the whole thing light reddish gray.
Color ❶ with dark sky blue and ❷ with earthen yellow. After depicting cracks with black, color ❸ with a base color of sky blue.

Continues on next page ▶

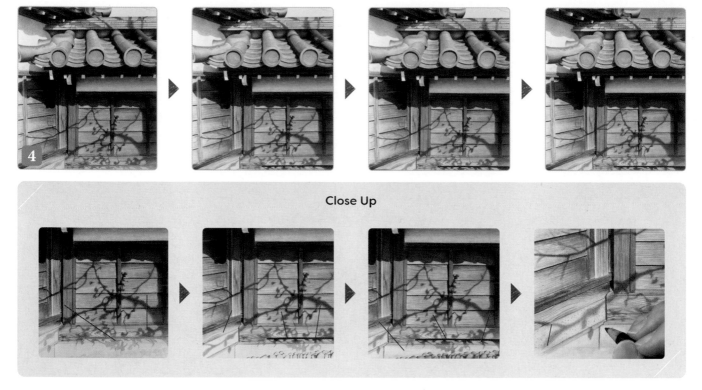

Close Up

Color ❹ with dark red, dark blue, orange, and yellow. After coloring ❺ with burnt umber and cream, add yellow. Color the shadows on ❻ with dark blue and each stone with light gray, gray, or reddish brown. Color ❼ with gray. Apply color gradation to ❽ with sky blue and reddish brown, and burnish (⊙ page 10) with white. Burnish with pale yellow, and color ❿ with dark blue, orange, yellow, and dark red. For ⓫, hold the colored pencil upright and color with staccato dots.

■ Light reddish gray · ■ Dark sky blue · ■ Earthen yellow · ■ Black · ■ Sky blue · ■ Dark red ·
■ Dark blue · ■ Orange · ■ Yellow · ■ Burnt umber · ■ Cream · ■ Light gray · ■ Gray ·
■ Reddish brown · □ White · Pale yellow

5 Color the sky
Color the sky smoothly with sky blue, holding the colored pencil flat, and darken it by adding dark sky blue. Then burnish with

white. At this stage, apply color gradation by making the sky blue the higher you go and white the lower you go. Color over the branches with dark blue and dark red.

■ Sky blue · ■ Dark sky blue · ■ Dark blue · □ White · ■ Dark red

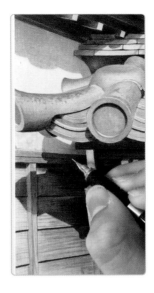

6 Make subtle adjustments to the overall drawing

Depict dirt with burnt umber, while looking carefully at the original image. Color with small movements to convey the naturalness. Then, insert highlights by shaving the colored surface with a designer knife. The trick is to shave the surface by holding the pencil as parallel to the paper as possible without applying any pressure. You should depict the fine lines with a sharp pencil.

■ Burnt umber

Completion

Look at the drawing from a bit of a distance. If nothing bothers you, it's completed.

irodoreal's Easy Photoshoot Method

Colored-pencil drawings tend to reflect light, so you need to be creative when taking photos of them. This section shows how to take beautiful photos using tools that are close at hand without having to resort to specialist expensive equipment.

Tools needed

- Colored-pencil drawing
- Camera—a smartphone is fine.
- Reflector board—create by combining three pieces of thick white paper.
- Use large pieces of cardboard, or something similar
- Desk lamp

Tips

- One light source is fine.
- Turn off extraneous lights.
- Prohibit direct light on the drawing.
- Light the drawing with light reflected off the reflector board.
- Shoot from right above the picture.
- Shoot with a wide-angle view and trim later.

Photoshoot Method *Using iPhone SE/iOS 14.6

1 Create a reflector board by sticking together three pieces of thick white paper. Stand the board up as an open-ended rectangle. You will take three A3-size photos.

2 Put the drawing in the middle of the reflector board and set up a desk lamp. Turn off the lights in the room.

3 Adjust the desk lamp so that it is shining on the reflector board, and check that the light is hitting the drawing evenly.

4 Hold the camera level with the paper and shoot from directly above it. The trick is to compose the photo so that it's larger than the paper.

5 Crop the photo on your smartphone.

6 Increase the brightness and contrast to complete the photo. If the whiteness of the paper bothers you, increase the highlights.

BAD EXAMPLES

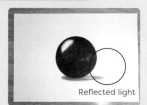

Light is directly hitting the drawing

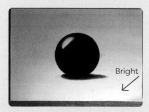

Part of the empty space in the drawing is bright.

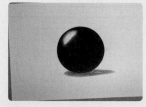

The photo doesn't contain all the paper, making it impossible to trim properly.

The paper and the camera aren't level with each other.

Meet the irodoreal Artists

Haru Otomi

Drew: Beetle (page 56) and Cat (page 74)

Started doing colored-pencil drawings in his second year at high school when he was fascinated by an acquaintance's paintings. As there was no one to teach him the techniques, he is entirely self-taught. In 2017 he started to post his works on social media, leading to a sudden increase in media coverage and job requests. Continues to work hard as a writer in his beloved Yamagata, driven by a desire to enjoy the things that he likes.

Twitter: @huwahuwa1_25

Instagram: haruru125_art

Ishikawa @ Colored Pencil

Drew: Metal Rings (page 44), Parakeet (page 62), and Snake (page 80)

Born in Chiba Prefecture. Performed in a comedy duo called "Ai-chan" for the Watanabe Entertainment talent agency. When he drew a picture on some photocopying paper with a pencil, the other comedian in the duo gave him a colored pencil and he started doing colored pencil drawings. Started posting his colored pencil drawings on social media in 2018. Draws mainly reptiles and other living creatures. Won the Rookie Award at the 55th Tokyo Tech Art Club exhibition.

Twitter: @jamjamjam4649

Instagram: ichanishikawa

Ryosuke Mika

Drew: Green Grapes (page 20), Tree (page 92), and Mailbox (page 98)

Born in Hyogo Prefecture. A fourth-year student at the Department of Fine Arts at the Osaka University of Arts. Started creating colored pencil drawings in 2019. Draws mainly everyday beautiful landscapes and ordinary scenes, and precisely expresses the colors that he has perceived with his five senses. Regularly presents his works in Osaka and Yokohama and promotes the appeal of colored-pencil drawing that can express precision and warmth.

Twitter: @3ryocp

Instagram: mika_coloredpencil

Bonbon

Drew: Apple (page 14), Fruit Tart (page 32), and Puppy (page 68)

Born in Osaka and now lives in Shiga Prefecture. Graduated from the Visual Concept Planning Department of the Osaka University of Arts. Now works as a colored-pencil artist and a colored pencil drawing instructor. Has a wide range of motifs and publishes his work on social media and at solo exhibitions, with the aim of drawing everything in nature. He holds classes at the Kyoto Shimbun Cultural Center and the Mainichi Culture Center, etc. Won the Grand Prize in the Colored Pencil Drawing General Section of the first Pencil/Colored Pencil Drawing Context organized by Hokusei Pencil.

Twitter: @bonbon20170916

Instagram: bonbon20170916

Miyakawa

Drew: Salmon Sushi (page 26), Gem (page 38), and Glass Bottle (page 50)

First started drawing colored pencil drawings as a hobby at high school. He specializes in trick art that looks 3D, and currently works as an office worker while continuing to create works with motifs such as "crushed plastic bottles" and "uneaten snacks." In the past, he has exhibited in science museums and has provided trick art for online ads.

Twitter: @miya_drawing

Instagram: miyakawadrawing

Licht

Drew: Clouds (page 86) and Wooden Walls (page 104)

Born in Hokkaido Prefecture. Currently at high school. Started drawing landscapes with colored pencils in July 2019 after seeing a landscape drawing by a certain colored-pencil artist. Likes detailed depictions and various types of light. Aiming to go to art college.

Twitter: @redepiction

Instagram: rihito1336

irodoreal

irodoreal is a group of colored pencil drawing artists whose photorealistic works are attracting attention on social media and in mainstream media. They are a group of up-and-coming colored pencil drawing artists who relentlessly pursue realism. The group was formed to propagate the appeal of colored pencil drawing, while all the while improving each other's skills through friendly rivalry. The group and its members have over 100,000 followers on Twitter. Since the fall of 2019, irodoreal has continued to appear at exhibitions and in various types of media.

Twitter @irodoreal

Nurieshiki Shashin nishika Mienai Iroenpitsuga Joutatsu Drill [Kihon hen]
© 2021 irodoreal
© 2021 GRAPHIC-SHA PUBLISHING CO., LTD.
This book was first designed and published in Japan in 2021 by Graphic-sha Publishing Co., Ltd.
This English edition was published in 2024 by FOX CHAPEL PUBLISHING
English translation rights arranged with GRAPHIC-SHA PUBLISHING CO., LTD. through Japan UNI Agency, Inc., Tokyo

Original Edition Creative Staff:
Book design: STUDIO DUNK (Madoka Tayama, Sayaka Funakubo)
Editing: Ken Imai (Graphic-sha Publishing Co., Ltd.)
Image collaborator: Yua (Twitter: @yunc24291)
Cooperation: Westek Incorporated, MITSUBISHI PENCIL CO., LTD., Watanabe Entertainment Co., Ltd.
Foreign edition Production and management: Takako Motoki and Yuki Yamaguchi (Graphic-sha Publishing Co., Ltd.)

English Edition Project Team:
Translator: Nick Bennett
Acquisitions Editor: Amelia Johanson
Managing Editor: Gretchen Bacon
Editor: Madeline DeLuca
Designer: Freire. Design SL

ISBN 978-1-4972-0674-8

Photorealistic Colored Pencil Drawing Workbook is a revised translation of the original Japanese book. This version published by New Design Originals Corporation, an imprint of Fox Chapel Publishing Company, Inc., Mount Joy, PA.

We are always looking for talented authors. To submit an idea, please send a brief inquiry to acquisitions@foxchapelpublishing.com.

Printed in China
First printing

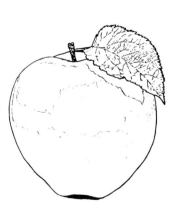

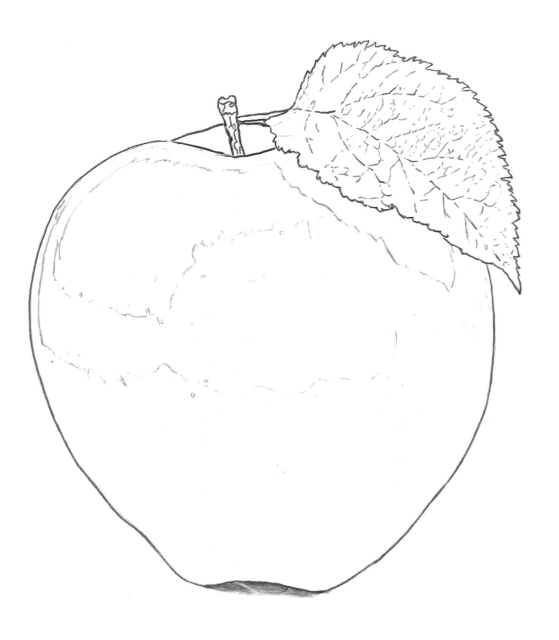

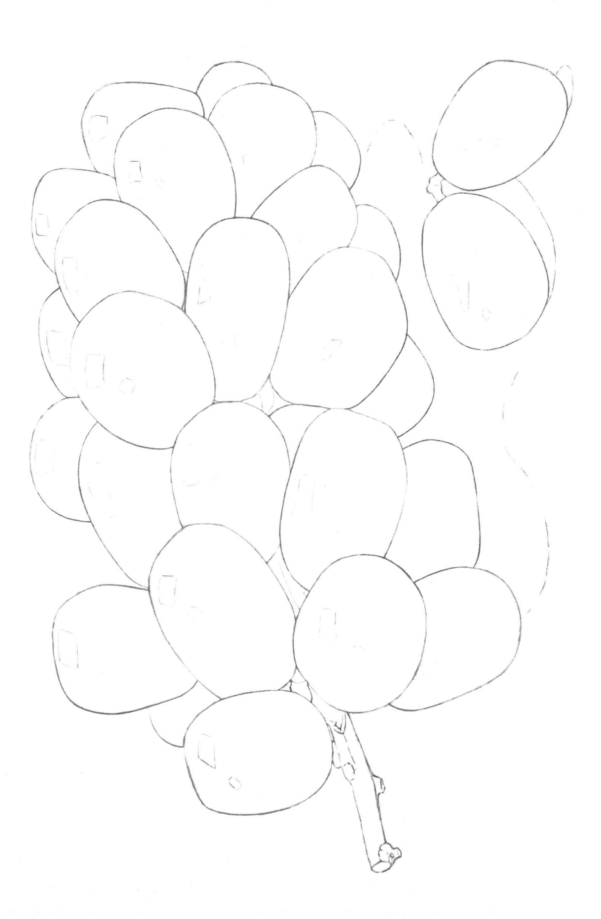

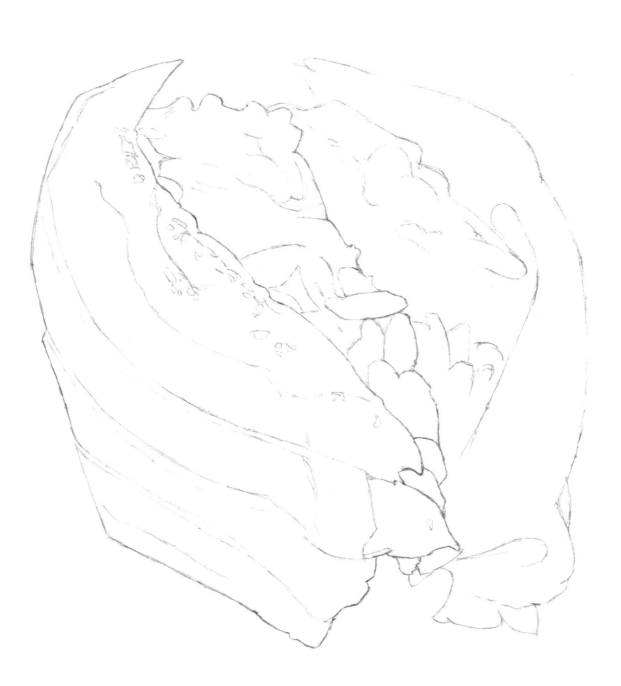

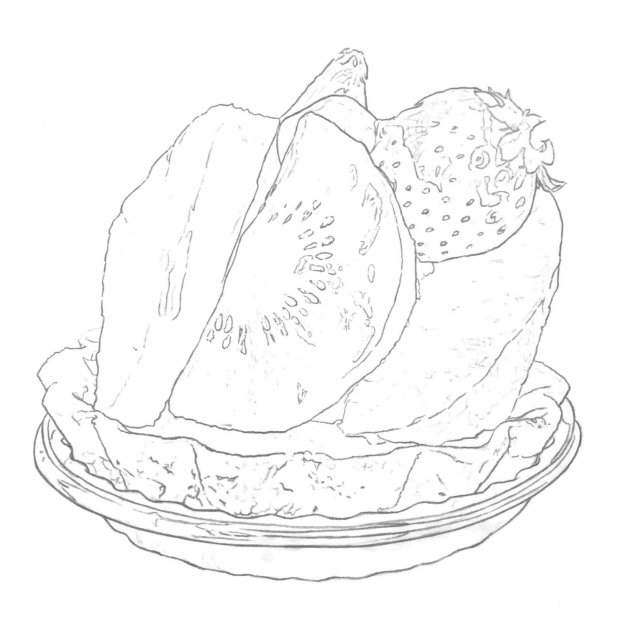

cut line

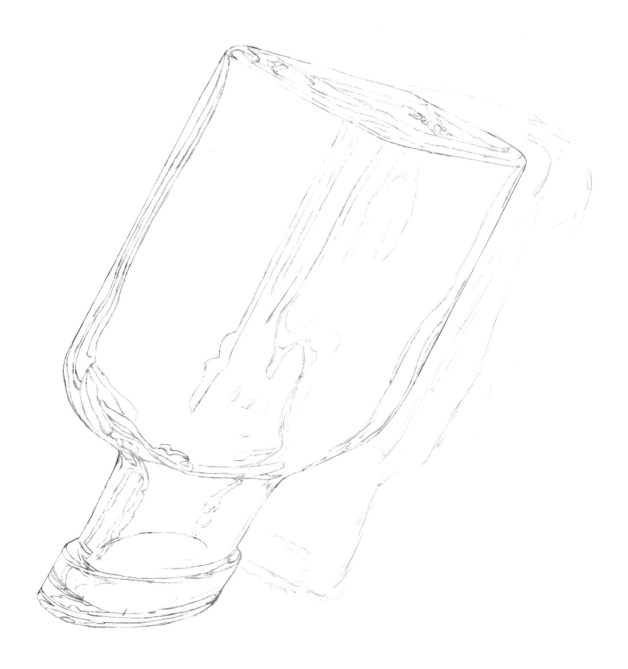

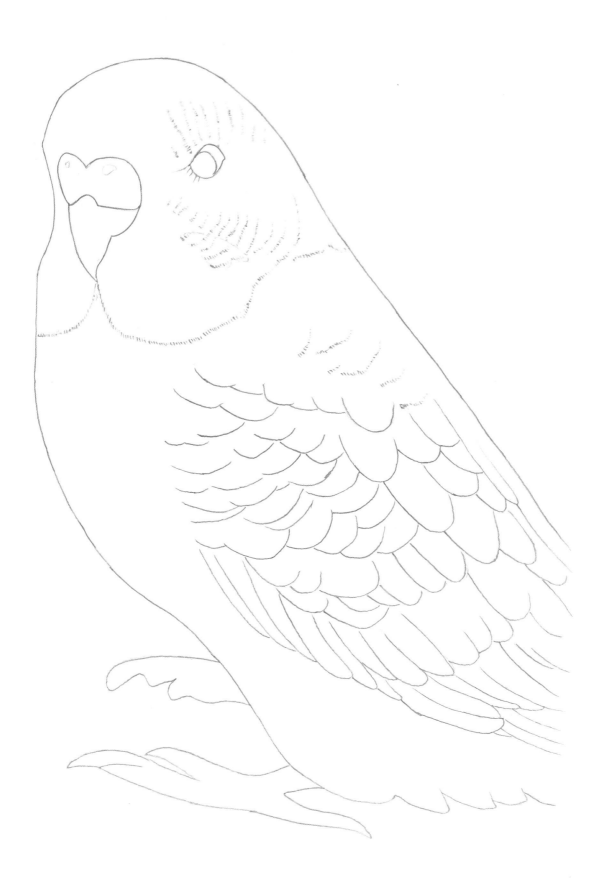

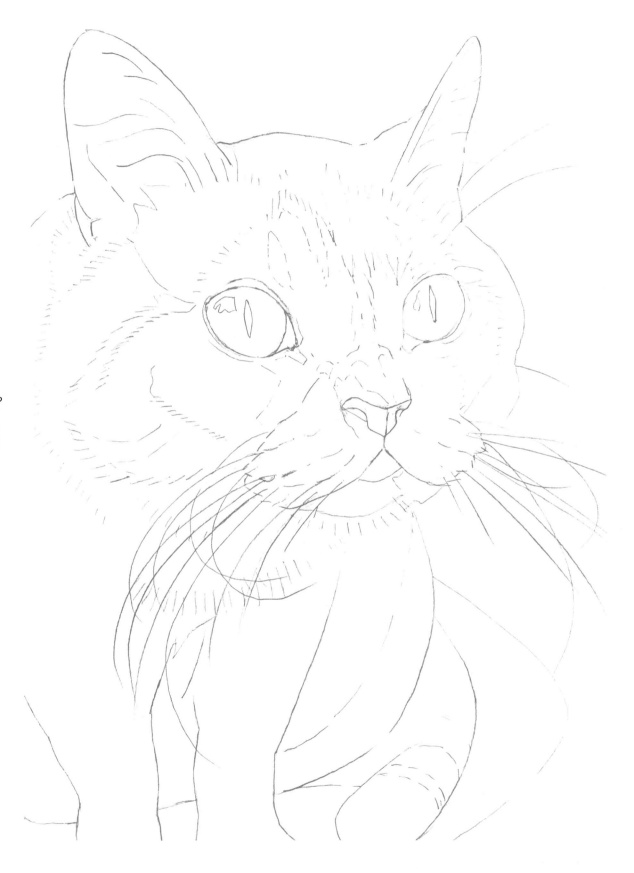

cut line

cut line